LEGENDARY L(

OF

TEMPE

ARIZONA

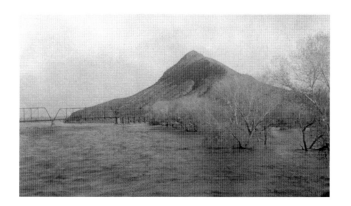

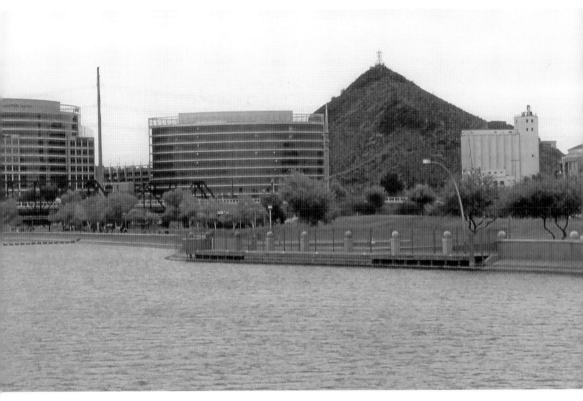

Modern Tempe

Today, private developers, the City of Tempe, and Arizona State University—Tempe's largest employer—are filling the banks of the Salt River with skyscrapers. The large buildings and modern conveyances, like the light rail, stand in stark contrast to the humble roots of a small town started by courageous pioneers who provided the foundation for what Tempe is and continues to become. (Courtesy of Stanley Parkinson.)

Page 1: Early Tempe

Long before Tempe and ASU grew to their current sizes, Tempe Butte—also known as A Mountain and Hayden Butte—was a blank slate with signs of life from people who lived here centuries ago. The Salt River flowed freely, sometimes permitting a safe crossing and sometimes at flood stage, as shown, making it dangerous even with the help of Hayden's Ferry, the early name of the Tempe community. (Courtesy of Tempe History Museum.)

LEGENDARY LOCALS
— OF —

TEMPE
ARIZONA

STEPHANIE R. DELUSÉ, PHD
WITH THE SUPPORT OF THE TEMPE HISTORY MUSEUM

LEGENDARY
LOCALS

Dedication

To those who serve others, often in obscurity, you are a legendary local to someone. You all deserve to be in these pages.

On the Front Cover: Clockwise from top left:
Finley Brothers, rodeo stars (courtesy of Tempe History Museum; see page 90), Lawrence Tenney Stevens, famous sculptor (courtesy of John Faubion, Lawrence Tenney Stevens Trust; see pages 98–99), Pat Tillman, athlete and war hero (courtesy of the Pat Tillman Foundation; see page 47), Ladimir "Ladmo" Kwiatkowski, kid's show television star (courtesy of the Kwiatkowski family; see page 89), Jerry Brock, businessman and philanthropist (courtesy of Jerry Brock; see pages 53–54), Elias women, pioneer family (courtesy of Tempe History Museum; see page 37), surfer at Big Surf (courtesy of Big Surf Waterpark; see page 88), Takayori Atsumi, world-class cellist (courtesy of Sally Atsumi; see page 97); Dwight Harkins, theater founder (courtesy of Dan Harkins; see pages 92–93)

On the Back Cover: From left to right:
Dwight Harkins, radio and theater innovator (courtesy of Tempe History Museum; see pages 92–93), Crimson Rims team (courtesy of Tempe History Museum; see page 83)

CONTENTS

ACKNOWLEDGMENTS

Unless otherwise noted, the photographs in this book are from the Tempe History Museum. Thus, my greatest thanks is to the Tempe History Museum, without which this book would not be possible. I am grateful to their whole team, directed by Brenda Abney, who is building on the 26 years of fine work under the leadership of the previous director, Dr. Amy Douglass. Special thanks to Joshua Roffler and Jared Smith for their insights, coordination efforts, and in reading drafts of this manuscript, and to volunteer Dan Thompson for his patient and careful scanning of images. If it is of interest to future researchers, the call numbers for the Tempe History Museum images used in this book are available in a list from the Tempe History Museum and from the author. Thanks also are due to historian Dr. Denise Bates for reviewing the manuscript; to the University Archives personnel at the Arizona State University Libraries, especially archivists Robert Spindler and Katherine Krzys for their ideas and support; to John Faubion, director of the Lawrence Tenney Stevens Trust; to Adriana Milinic of the Musical Instrument Museum; and to the Arizona Historical Society.

I also am humbled by, and thankful for, the work of all prior historians of Tempe and the gracious community members who shared time, thoughts, and photographs. These include the many people whose names are noted in the courtesy lines of the photographs and many others who visited with me or shared photographs that are not included in the book. Limited space precludes listing everyone, but extra thanks are due to, in alphabetical order, *Arizona Business Today*, Shirley Blanton, Jerry Brock, Peggy Bryant, Martha (Dumas) Bunger, Rudy Campbell, Nita Craddock, Kathy Dominguez, Ellen Ellis, Debbie Elman, Molly Enright, Sue and Bob Enright, Neil Giuliano, Jeff Golner, Ellen (Pohle) Hardin, Dan Harkins, Colleen Jennings-Roggensack, James Albert Kitts, Vic Linoff, Harry Mitchell, Kory Nakatsu, Hans Olson, Wendy Reeck of Tempe Elementary School District No. 3, Gayle Shanks, Joe and Sandy Spracale, *The Daily Courier*, and Victor "Mike" Wilkins. Many in Tempe lead interesting lives and do noteworthy things that cannot all fit in this slim volume, which captures just a cross-section of a great people. I am proud to be a native Arizonan and to have called Tempe home for most of my life.

Special thanks go to Stanley Parkinson for his steadfast support in all things, and his efforts in reading the manuscript, compiling the index, and taking contemporary photographs.

INTRODUCTION

Tempe is a city that celebrates life, variety, and innovation. The pioneers who struggled to earn a living and develop their land would be delighted to see how the community seeds they planted grew into a thriving city making meaningful contributions to a global society. They would be surprised to see how a 160-acre town, remote and distinct from neighboring areas, grew to 40 square miles tucked into the valley's growing urban sprawl of over 9,000 square miles. Those early pioneers would be proud of how Tempeans continue to reinvent Tempe—most recently with the continued development along Tempe Town Lake, fittingly near where the town first began.

Much of what happens in Tempe ripples through to a larger audience interested in the city's progressive leadership and the innovations of the world-class research university within its borders. For instance, the rubber-dammed 261-acre Tempe Town Lake brought a riverbed to life that had been mostly dry for decades after the dam system was developed. The pros and cons of the project's construction and repairs are frequent topics of new stories, as is its success. Indeed, Tempe Town Lake reportedly draws 2.7 million visitors a year, making it the second-biggest tourist site in Arizona after the Grand Canyon. Its success paved the way for similar projects elsewhere.

Similarly, the work done at Arizona State University (ASU) is well regarded on the international stage, continuing the legacy of the Arizona Territorial Normal School (ASU in its infancy). The normal school partnered with the communities in ways that impacted the territory, drawing students and faculty from afar as it grew. Arizona State University is now the largest university in the country, with over 83,000 students in 2014—and growing. The effects of education on each of the thousands of students who come through Tempe each year to learn are immeasurable, not to mention the life- and society-changing research and creations its faculty and graduate students generate. The students help keep Tempe vibrant and young while here, and they usually continue to be fans of not just the Sun Devils but of the city, often staying to live in the Valley of the Sun or returning as tourists or to retire.

But today's success started long ago. Thus, it is hard to overestimate the impact of Charles Trumbull Hayden on Tempe's beginning. Imagine growing up in the cool green of 1825 Connecticut and striking out to the desert Southwest with its dry air, dusty trails, and clear blue skies. Hayden did so incrementally, teaching school in different states as he moved west until, in 1848, he began hauling freight from Missouri to the desert along the Santa Fe Trail, settling as a merchant in Tucson in 1858, where he also served briefly as a judge, successfully conducting business with settlers, military posts, and miners. It was a good day for the valley when, in 1866, the 41-year-old was stranded at the flood-stage Salt River on a business trip to Fort Whipple near Prescott. Climbing 300 feet up Tempe Butte (also known as Hayden Butte), he saw what the early Native Americans had centuries before when the Hohokam built hundreds of miles of irrigation canals in what is now metropolitan Phoenix; this valley had awesome potential. And he was just the forward-thinking man to help develop it in that era.

Hayden made plans and acted on them, and is commonly considered the founder of Tempe. He certainly deserves credit for optimizing the area and filing the paperwork necessary to stake claim to water rights for Hayden Milling and Farming Ditch Company and declaring a homestead for 160 acres of land west of the butte in 1870. Hayden quickly joined his canal-building activities with others who were engaged in canal-construction businesses in the valley, and ultimately built a store, a home, a grain mill, two blacksmith shops, a carpentry shop, and three stores on neighboring Indian reservations. It is no surprise that the first name the US Post Office accepted for the area was Hayden's Ferry, after a cable-operated ferry Hayden built to cross the Salt River in 1871. The name was changed to Tempe in 1879 for a classic area in Greece and after some of Hayden's other businesses.

Hayden's foundational role in anchoring commerce is certain, especially after he centered his freighting operation in Tempe in 1873. Yet he did not do it alone. Hayden's visionary plans were shared by and carried out with help from the Mexicans who lived here before him and by others who quickly came to the happening place, including the Mormon settlers he made feel welcome. In fact, Hayden was known to be supportive and kind with local Akimel O'odham (Pima) and PeePosh (Maricopa) Indians when many others were suspicious of, if not vicious toward, nonwhites during a time of unrest during the settling of the West. Hayden was well loved by the local Hispanics, too, who also sometimes faced various forms of stereotyping, perhaps due to after-effects of the Mexican-American and Civil Wars.

As time progressed, more settlers gained influence in town and contributed in various ways. For instance, without the contributions of early townspeople and the political savvy of John S. Armstrong, the Territorial Normal School at Tempe would not be. Hayden continued to care deeply about the community, staying active in the civic realm and advocating strongly for education at all levels, even as his influence began to wane toward the end of his life in 1900. (For instance, Hayden disagreed with the idea of incorporating Tempe, yet that occurred in 1894.) The next wave of settlers and second-generation Tempeans continued to make their marks locally and beyond, including Charles Trumbull Hayden and Sallie Calvert Davis's son, Carl Trumbull Hayden. That trend continued with each generation, as each decade brought new challenges and new sung and unsung heroes, some of whom will be mentioned in this book and many of whom deserve books of their own.

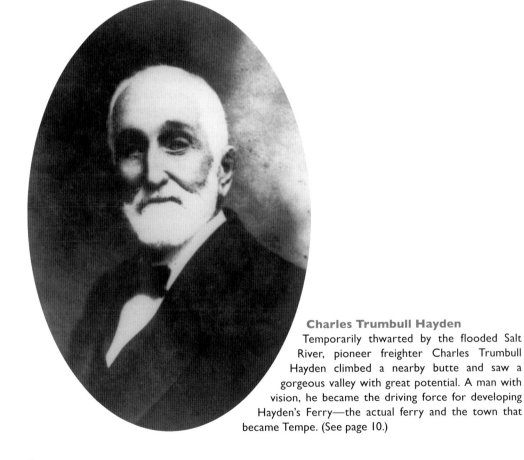

Charles Trumbull Hayden
Temporarily thwarted by the flooded Salt River, pioneer freighter Charles Trumbull Hayden climbed a nearby butte and saw a gorgeous valley with great potential. A man with vision, he became the driving force for developing Hayden's Ferry—the actual ferry and the town that became Tempe. (See page 10.)

CHAPTER ONE

We Built This City

Life in the 19th century and early 20th century was tough for many reasons, and settlers had plenty to be proud of given the risks they faced and their achievements as they adjusted to the sparsely inhabited, or uninhabited, spaces where they moved. At first, they were even getting used to being outside of America itself, as the Arizona Territory was the Wild West. That pride might be one reason why, when reading early histories of the United States, it seems more common to share blame than credit when sometimes white settlers are praised and others are not mentioned, diminished, or even vilified. Yet the Native Americans and non-Anglo families played important roles and were in Arizona long before the United States claimed the area as a territory—making the Hispanic settlers US citizens in the mid-19th century—and even longer before Arizona became a state in 1912.

As more Anglos moved into the Arizona Territory, many assumed a dominant attitude over the Hispanics and used an Anglo set of beliefs and legal practices that privileged themselves and resulted in events from simply renaming settlements to what they preferred—often after themselves—to more egregious deeds like taking land and rights from earlier residents. This continued a practice begun when others previously denied the Native Americans what many would consider their rightful place. Although certainly there were some warlike encounters between Anglos and Native Americans in the area, there was an elasticity to the relationships between area settlers and certain tribes, like they had with the Hispanics in the valley, moving between cooperation and prejudicial discrimination usually as it suited the Anglos. For instance, the chances Mexicans could hold on to land they thought was theirs was often due to legalities, but also by how well they got along with the richer, more politically powerful Anglo leaders.

Initially, in the late 1800s, Mexicans were generally respected as people pulled together for the common good and as it just made good sense to be friendly to one's neighbors in the isolated location. People often have more in common than meets the eye, and working shoulder-to-shoulder on projects gives folks not only a shared goal but time to get to know one another. Sadly, as more Anglos arrived, the influence of the Mexican families declined, as it is harder to maintain true friendships with many people as a community grows, and the new arrivals did not always get that side-by-side working contact that the earliest settlers did. So prejudicial times have waxed and waned in Tempe, as they have anywhere and often in response to outside events. But, by and large, the citizens worked well together and remembered that building a city is more than clearing land, digging canals, and laying blocks. It includes building a community—one relationship at a time or in honor of entire groups—that is safe and friendly for all. Many people helped build this city in a variety of different roles.

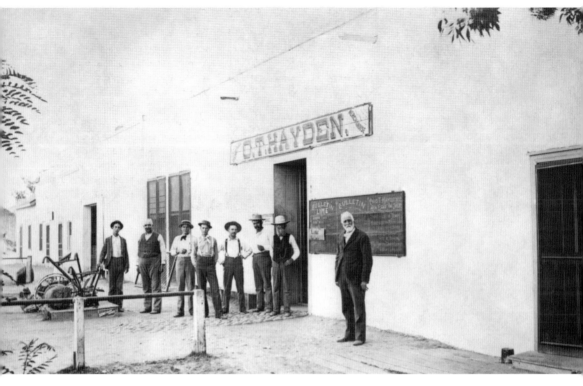

Hayden Begins

Hayden's 1871 store was a 14-by-16-foot shop of willow poles and wattle-and-daub, later expanding to the adobe structure pictured here. Several other pioneers worked at the store at one time or another, then sometimes opened their own stores. Hayden (far right) began building a simple adobe home connected to the store in 1873, to which rooms were added over time. It soon was called La Casa Vieja (the old house).

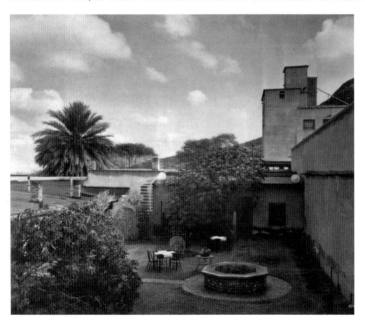

La Casa Vieja

The old house was the longest continuously inhabited dwelling in the valley. Most recently, it housed for 58 years Monti's La Casa Vieja restaurant, which closed in 2014. The historic portion of the home—an iconic image of Tempe—is to be retained amidst a major redevelopment project for the surrounding property. Shown here is the inner courtyard and a glimpse of the more modern mill in the background.

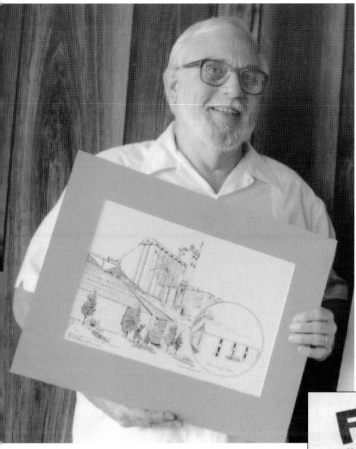

Hayden Mill
Tempe artist Richard Nearing—active in the Tempe Art League, Arizona Artists Guild, and on the Tempe History Museum board—holds his drawing of Hayden's mill. It shows the 1918 version—the oldest cast-in-place reinforced-concrete building in Tempe—which replaced the original 1874 version that burned in 1917. Inset in his drawing is the mill as it appeared by the mid-1890s.

Hayden Mill Flour
The mill produced many popular products, including Rose brand flour, and its 12-story silos are an iconic image of Tempe. The silos are to remain, albeit altered, during renovation, as the mill, which closed in 1998, is slated to become a mixed-use property, including hotel and office space. The Hayden Flour Mill name is now being utilized by a new miller intending to honor it by milling heritage grains.

11

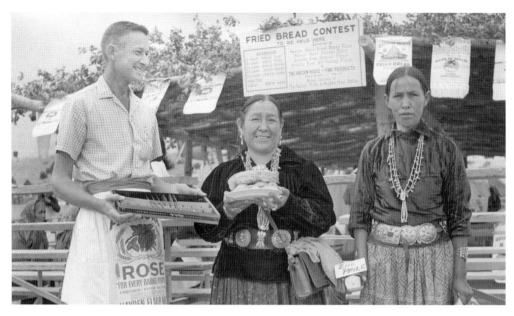

Indigenous People

The Hohokam, the first known settlers of the area, left 500 petroglyphs (like the one pictured below right) on Tempe Butte, pottery shards, and the remnants of canals that inspired later settlers to reuse them to irrigate their farms. Hayden had a good relationship with Native Americans, except when forced to fend off attacks during his territorial-day travels. Hayden took in an Indian child who had been lost during a skirmish. A bond grew, and Hayden often traveled with him or sought his advice before sending out freighting teams, as his local knowledge helped Hayden reduce the chance of loss of life or property to raids. The photograph below of a Maricopa woman was found in Hayden's things. The Hayden family continued the positive relationships, as evidenced by Hayden's grandson Larry, pictured above with winners of a fried bread contest using Hayden Mill flour.

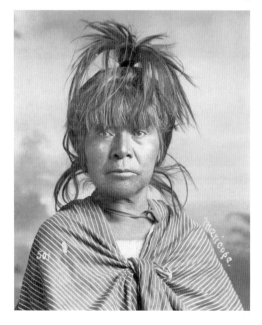

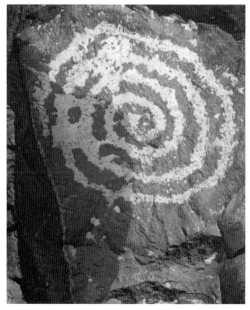

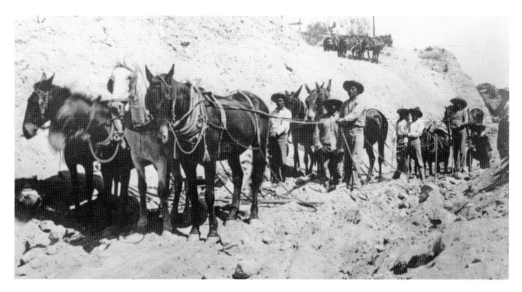

Hispanic Presence

Hayden also worked well with Hispanics, who recall "Don Carlos" with fond respect. He built row houses near the river for laborers such as the Mexicans above, as they helped build and run his businesses. Hayden routinely welcomed them into his home for meals. These families generally came from Sonora, Mexico, fleeing political unrest, often settling near Tucson and Tubac and moving again when dangerous conditions pressed them to seek more safety in places like Florence, Solomonville, and Tempe. Some were from elite Sonoran families that rose to dominance during Spanish colonization of Mexico, bringing wealth or quickly earning it, as the Cresencio Sigala family parlor below shows. Others were more working class, yet all families had to work hard during the territorial days, as most everything they needed came from their own ingenuity and labor.

Working Together

While about half of Tempe-area residents were Mexican between 1870 and 1900, as Hayden's Ferry grew, they became unhappy with the growing prejudice felt in town. In an effort to help protect their interests, William H. Kirkland, one of Hayden's partners in the Tempe Irrigation and Canal Company (at right, seated on the left) set aside 80 nearby acres of land east of Hayden and south of the butte to sell lots to Hispanics and donating funds from the sales to build them a church. The area became the San Pablo Barrio. Priests from Florence regularly came to conduct mass starting in 1872, until the plain adobe church—Our Lady of Mount Carmel—was built at the base of the butte in 1880, humbly plastered and whitewashed only on the front wall. (Right, courtesy of the Arizona Historical Society.)

Sotelo Family

Tiburcio Sotelo, son of Lt. Ygnacio Sotelo, the last commander of Tubac Presidio, brought two sons and a nephew to Tempe—the first Mexicans to arrive in Tempe for whom there are records. They helped construct the first canal on the south side of Salt River. Sotelo bought a 160-acre quarter section on the southeast corner of Rural Road (earlier known as Canal Road) and what is now University Drive (previously Eighth Street and Transmission Road at different times).

He died of illness in 1871. Both sons died that year as well: Feliciano, 23, from an Apache attack as he carried mail on the Tucson-Maricopa route, and Jose, 23, from drowning on his horse in the Salt River as he tried to escape an attack. His widow, Manuela Sánchez Sotelo, above, brought her nine remaining children (a son, five, and eight daughters ranging from four to 20) to Tempe to work the land.

With the help of Winchester Miller, who had worked with her husband, she, in 1890, managed to retain title to her land in a time when many Mexicans were unable to do so. She subdivided the acreage into the 25-parcel Sotelo Addition and later acquired more property in Mesa, Gilbert, and Queen Creek. In 1892, an ice plant was built at the east edge of her land, which shortly after became a creamery and now houses the Four Peaks Brewing Company in part of the remaining buildings.

Her family grew wheat, beans, squash, and corn to sell as well as flowers and flavorful and medicinal herbs. She had a good working relationship with Hayden and was welcoming to any family that moved into the area, teaching them how to survive in the challenging terrain. Often considered the "Mother of Mexican Tempe," her kindness and business skills were highly respected. Her eldest daughter, Maria, was educated in a private Catholic school in Sonora, and she caught the eye of Winchester Miller, the former Civil War soldier whose first wife died and whose teenaged children were being raised by their grandparents in Iowa. A romance was born. (Courtesy of the Chicano Research Collection, Arizona State University Libraries.)

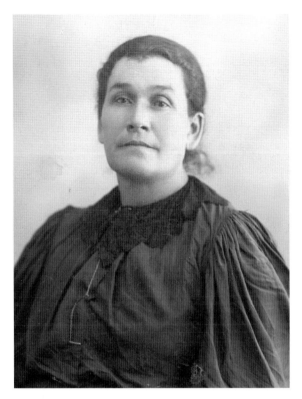

Winchester and Maria Miller

Winchester Miller, a civil engineer and former Confederate soldier, arrived in Tempe in 1869, ultimately becoming the president of the canal company where he worked. He liked the Sotelos and sought Manuela's permission to court Maria, marrying her in 1873, when he was 37 and she 20. They first lived in a settlement northeast of Tempe in a one-room adobe home with porthole windows and a fortified door, later moving to Miller's property between University Drive and the river, just north of the Sotelo property.

Their farm grew wheat and vegetables in addition to fruit from a 35-acre orchard. He was also a freighter, county sheriff in the 1870s and 1880s, and active in Democratic politics—well known for representing Mexican interests. The Millers led a good life in their big two-story adobe home, and on one of Miller's freighting trips to Yuma he bought for Maria a sewing machine, the first one in Tempe, which had first been shipped up the Colorado River from the Gulf of California to Yuma. The couple had 10 children before Winchester died in 1893 of a foot injury from a fall; the same foot was crushed by a donkey, resulting in blood poisoning and amputation.

Active advocates for public education, the Millers must have been proud that their daughters Anna, born in 1873, the first recorded Anglo Mexican child born in Tempe, and Clara were the first Mexican American alumni of the Arizona Territorial Normal School. Four of their siblings attended as well, and their parents contributed to the $500 collected from community members toward adding 15 acres of land to the five acres George Wilson donated for the school. The Territorial Normal School (TNS) changed names as it grew, including Tempe State Teachers College (TSTC) in 1925, Arizona State Teachers College (ASTC) in 1929, Arizona State College (ASC) in 1945, and ultimately Arizona State University (ASU) in 1958. Maria died from heart disease at 84 in 1937, living long enough to enjoy many of their descendants.

One of Winchester Miller's grandchildren from his first marriage, Ruby Haigler Wood, moved to Tempe as a child, starting first grade in Rural School, graduating high school in 1912, and completing the two-year teacher's course at the normal school. As a teacher in the village of Guadalupe in the early 1930s, she helped the village get its first water well and pump. (Courtesy of the Chicano Research Collection, Arizona State University Libraries.)

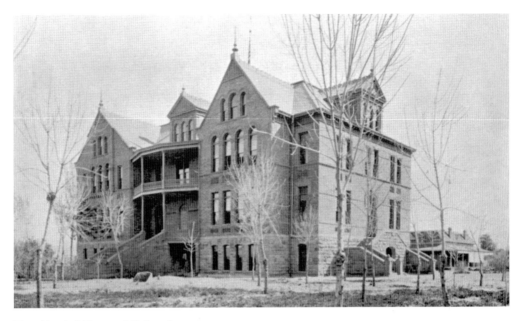

Territorial Normal School

When the Miller children attended the normal school, the 1898 three-story Old Main building (above)—the first building in Tempe to have electricity and the largest building in the valley for decades—was there, rather than solely the original 1886 building (below and at right above). The first class in the 1886 building was 33 students, 17 of whom were Mormon settlers. At first there was a two-year curriculum to train teachers, for which the territory was desperate. That grew to a three-year program. Community and faculty input led to increasingly rigorous classes, programs, and degrees year after year, until the institution grew into the current Arizona State University. The Territorial Normal School anchored the community in a new way and drew new residents to attend or teach at the school. ASU and Tempe are inextricably intertwined.

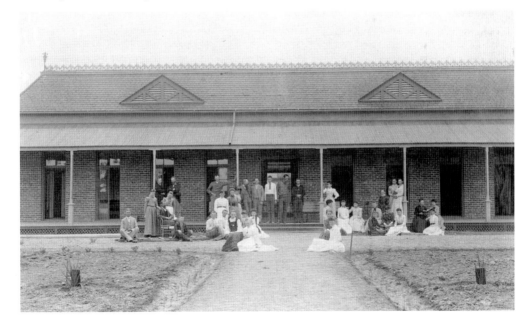

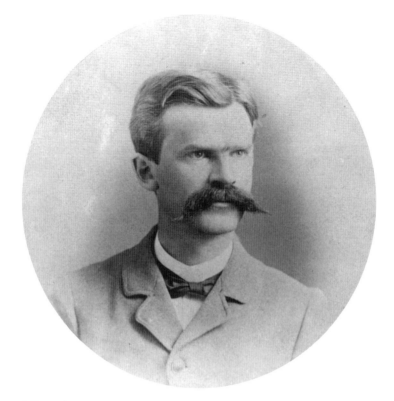

John Samuel Armstrong

The Territorial Normal School became a reality due largely to the political savvy of John S. Armstrong, backed by a community that pulled together to help make it happen. He was elected to the 13th Arizona Territorial Legislature in 1884, serving as chairman of the House Committee on Education. Before his 1882 arrival in Tempe, he served as superintendent of the Indian School Agency for the Pima Reservation in Sacaton, where the former newspaperman and his wife, Sarah, also taught after relocating from Virginia in 1879.

Shortly after their arrival, a mandate from Washington, DC, required male Indians to cut their hair, discontinue face painting, and cease making cactus liquor. This caused embittered refusals, and an Indian informant alerted the settlers that if the mandates were not withdrawn, a group of about 1,000 Indians from the Salt River valley vowed to massacre the Pima Agency settlers in the night. With no telegraph to send for help, Armstrong sent the women across the desert by wagon 15 miles to Casa Grande to safety and to wire for assistance from Major Chaffee at Fort McDowell, about 30 miles away.

As the 10 men waited through the night, they reached out to nearby head chief Antonio Azul (Ervaatka in his own language), who was known as a great orator. He interceded on their behalf, ready to orate for hours until help could arrive. At daybreak, they saw the great band approaching, and their chief made clear his demands. Azul told him that he had been to Washington, and the white men were like the sands of the sea, so numerous that if these 10 men were killed, sadly, a great revenge would be exacted.

At high noon frustrations reached a boiling point, but just as the men were raising their weapons and the women on the outskirts began their war songs, a bugle sounded and Major Chaffee arrived with two companies of cavalry. Mutual bloodshed was gratefully averted, and realizing some of the error of their ways, sometime later Washington chose to let the Indians decide whether or not to paint their faces and cut their hair, inducing cooperation by offering agricultural tools and other supplies to those who cooperated. Cactus liquor, however, was still forbidden. The Armstrongs continued teaching in Sacaton two more years before moving to Tempe. (Courtesy of John S. Armstrong III.)

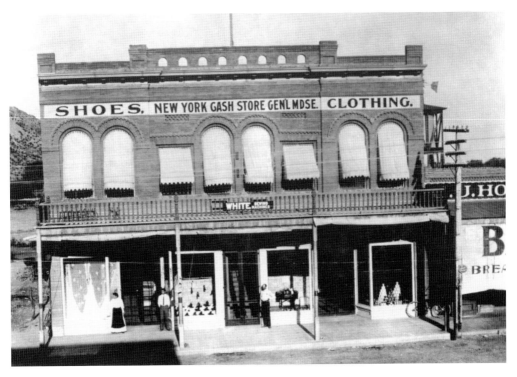

Armstrong's Legacy

Armstrong bought an adobe house from Hayden for $150 and acquired water rights. He co-owned the Petersen, Armstrong & Co. store and the building pictured above with Niels Petersen and was cofounder and first president of the Farmers' and Merchants' Bank of Tempe. As a territorial legislator, in addition to the normal school for Tempe, he secured the insane asylum and brought the first railroad to Phoenix. He used his fluency in the Pima language and friendship with Chief Antonio Azul to negotiate with the Pima and Maricopa to let the tracks cross their land. Tempe's passenger station (below) was slated for the alfalfa field behind Armstrong's house, a quarter mile from Mill Avenue. His family left to go back East in 1893, where he was a financier and presidential campaigner for friend Woodrow Wilson. (Above, courtesy of John S. Armstrong III.)

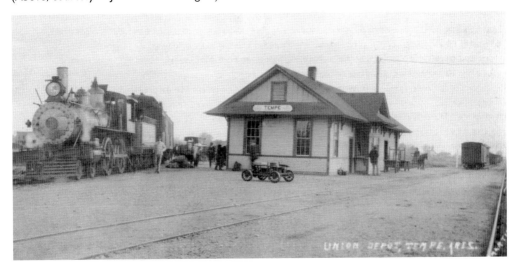

Juan Soza

Juan Soza (right, with son Juan Sotelo Soza Jr.) worked on Tempe canals, earning him water rights to irrigate 80 acres of land west of Hayden's Ferry. Many early pioneers traded labor for water rights. His life also included working at the flour mill, scouting for the US Army, driving a stagecoach between Tempe and Prescott, and carrying mail between Tucson and the Phoenix valley.

Early Tempe

A typical canal, until concretization, seeped water, to the delight of nearby foliage. This African American man was likely welcome in town during the day as a laborer but would face challenges when it came time for socializing, whether or not official sundown laws were in effect. After the world wars, prejudices began to reduce toward Hispanics and blacks, but it ramped up against Asians in World War II.

Roosevelt Dam

Mariano Gonzalez and his brothers, farmers from a wealthy Sonoran ranching family, brought their skills to Hayden's Ferry in the 1870s, initially helping build the canals. Mariano claimed land and built his wife, Maria Antonia Ramirez, an adobe home, which still stands facing the river on West First Street. In 1875, their daughter Mariana married Canadian arrival James T. Priest (left), after whom the street is named. Priest was influential in the Salt River Valley for donating funds for the Territorial Normal School land and helping to build Our Lady of Mount Carmel, and as one of five men who initially helped plan the Roosevelt Dam. Roosevelt's speech from the normal school steps in 1911 about the dam was memorable. Below, Mayor Neil Giuliano (center) presents a photograph of the event to Pres. Bill Clinton in 1996. (Below, courtesy Neil Giuliano.)

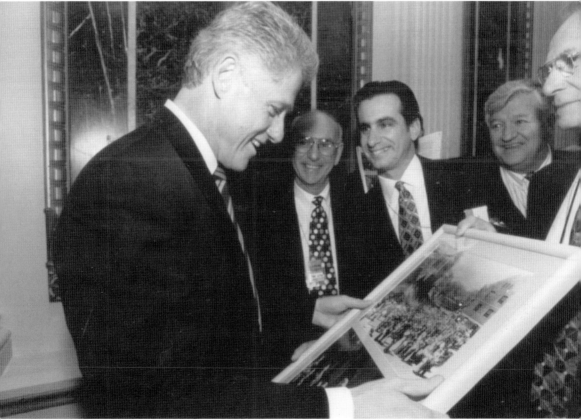

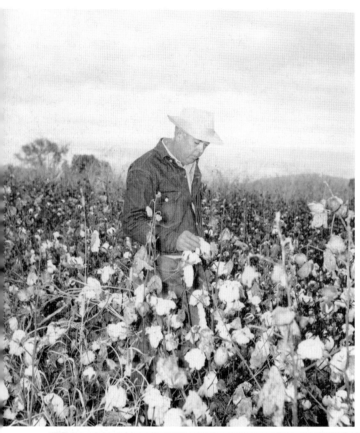

Cotton

The dam changed water use in the territory and contributed to the case for statehood. Previously, something like an ostrich farm was profitable due to its low water needs and the high price ostrich feathers brought for lady's fancy attire. After the dam and with the arrival of World War I, the feathers were seen as a wasteful luxury. The dam allowed for agricultural expansion, and water-hungry cotton became a major crop. At left, longtime resident Leo Ramsey tends his field, and below, Charles Martin Sr. (front) grades cotton in Tempe around 1915. The world-class cotton drew visitors from similar latitudes, such as Libya, to learn from valley farmers and the research done at the experimental farms of both Arizona State University and Tucson's University of Arizona. ASU's 320-acre farm became the ASU Research Park at Price Freeway and Elliot Road.

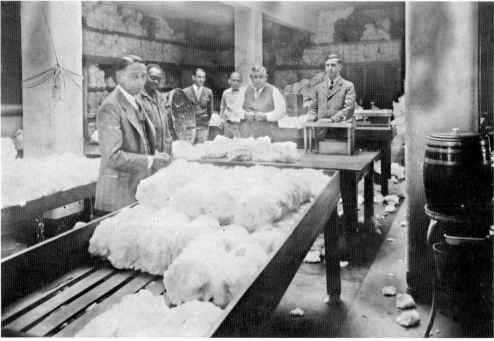

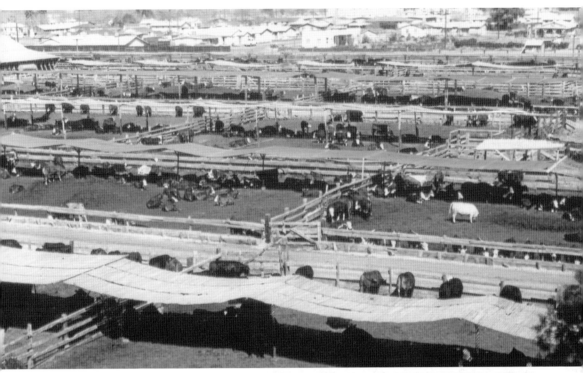

Arizona's Five Cs

Cattle ranches and dairy farms were common in the valley, such as the McElhaney ranch on Broadway Road, seen above with modern buildings encroaching as Tempe and ASU expanded and replaced older homes and farms with new public and school buildings and higher-density housing. All manner of fruit had been grown before the Roosevelt Dam was built, using water from irrigation ditches and natural rainfall, with early pioneer accounts mentioning, for instance, dates, peaches, apricots, figs, and grapes. But citrus became so dominant it is one of Arizona's Five Cs—cattle, cotton, citrus, copper, and climate—with the Valley of the Sun scoring well on all except copper. At right, in the 1970s, horticulturist Robert Hilgeman, a specialist in citrus and dates, studies data about the orchards for Tucson's University of Arizona farm in Tempe.

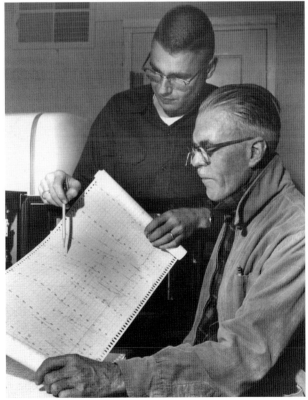

23

Industrious Goodwins

The Goodwin family engaged in many pursuits. In 1895, James Goodwin ran a streetcar from the flour mill south to Eighth Street/University Drive, then east to the canal. When the railroad came, the youngest brother, Garfield, guided folks to their destinations for 5¢. Two Goodwins started a brickyard, and Tom and Will ran a grocery at Mill Avenue and Fourth Street until Tom returned to farming. Will opened the Goodwin Opera House on Fifth Street next to the old city hall, showing silent movies—the first show business in town. Garfield (left) ultimately ran the Wells Fargo Express Company for 22 years while also running the Goodwin's Novelty Store, below, which carried Indian arts and crafts, until his death in 1944. Larry Miller ran it until 1965.

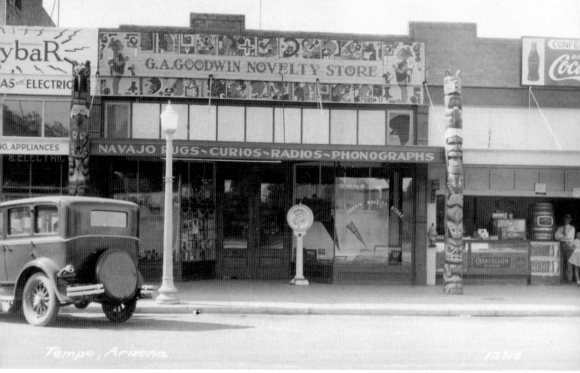

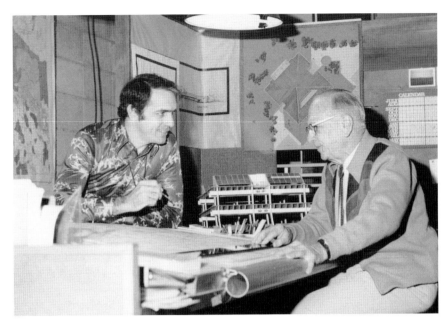

Goodwin Next Generations

The Goodwin Stadium, the predecessor of Sun Devil Stadium, was named after Garfield Goodwin, who played football on the normal school team and was an advocate for education. His son Kemper (above right) became an architect in town, designing many early buildings, including Tempe High and McClintock High. Kemper's son Michael (above left), a Tempe High graduate, followed the family—and Rotary Club—philosophy of "service above self" and in his father's footsteps as an architect. He designed many Tempe buildings in the 1960s and 1970s, including schools such as Marcos de Niza and Corona del Sol and the award-winning upside-down pyramid city hall building (below) in 1971, and was selected as a fellow in the American Institute of Architects. In later years, he spent more time as an artist and sculptor and became active in a theater company for adults with special needs. (Below, courtesy of Stanley Parkinson.)

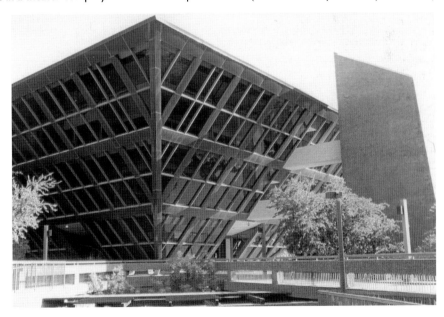

Curry Family

Building and repair supplies often came from the Curry Hardware store, until the family closed it in 1976. Michael Edward Curry Sr. founded the Tempe Hardware Company on Mill Avenue in 1906 in an 1898 building designed by James Creighton. The three-story building still stands at 520 South Mill Avenue, owned since 1981 by architect, preservationist, and musician Stuart "Stu" Siefer. The building, especially the second floor, called Curry Hall, was a center for civic life and was used by various groups over the years, including the city council, schools, Rotary Club, Knights of Pythias, church groups, temperance organizations, and more. Curry and his wife, Mary Carr, had twin boys named Ed (Michael Edward Jr.) and John. His grandson, Dan, is seen below helping a customer in the 1950s. (Below, courtesy of Harry Mitchell.)

Curry Legacy

The Curry boys, naturally, grew up. Ed became a US Army lieutenant colonel, serving in the Arizona National Guard and the Arizona House of Representatives from 1932 to 1940. John became the director of Work Projects Administration (WPA) projects in the area, some pictured below, including ASU's Moeur building—the only adobe building on campus—and the Welfare Sanitarium/tuberculosis hospital, seen at left with the Curry brothers and Sue Greer (wife of Joseph Madison Greer) at the 1934 building dedication, on Curry Road at the hilltop site where ASU's community services building now stands. John also volunteered for Tempe's fire department for 50 years, served on the city council for eight, and was on the city's first planning and zoning commission.

Season's Greetings

To:- JOHN CURRY DIST. DIRECTOR

1936

FROM:-

Aguilar Family

As the city grew, new roles developed. John Aguilar (above left, with Skip Moyer) was hired in 1973 to keep an eye on the social and economic needs of the community, with emphasis on youth, minorities, and other disadvantaged groups. He interfaced with many community groups and official agencies, later serving as the city's affirmative-action and employee-relations officer and then the first fair-housing officer, inspecting federally subsidized low-income housing to ensure it was safe, sanitary, and equal-opportunity. Aguilar saw many places in Tempe he had never seen before, even after living in Tempe his whole life. His younger brothers were top athletes at Tempe High, playing several sports each. Ray, in the letter sweater below, was 1957 homecoming king and hailed in local papers as the school's "greatest all-around athlete." (Below, courtesy of Harry Mitchell.)

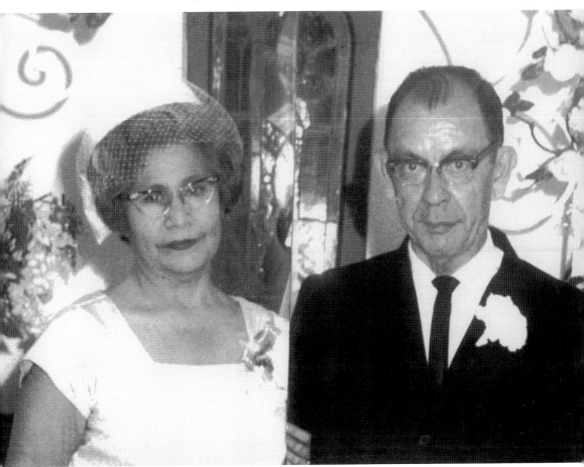

Aguilar Legacy

John and Ray's parents, Juan and Concepcion Aguilar, moved to Tempe from Mexico via Phoenix in 1933. In Tempe, they first shared a tent with Mike and Mary Gamboa's family. Juan built a house—10 cement bricks a day—which they sold in 1953 as the college expanded. Juan worked various jobs to support his big family until securing work at the Eighth Street School, beginning a long career at Tempe schools and resulting in a school named after him and his wife. Their 10 children share pride in the family name and heritage, a heritage celebrated at the 11-day Tempe centennial celebration in 1971, especially on Mexican Fiesta Day with organizers—under the leadership of Bob and Sue Enright—(from left to right) Rudy Arroyo, Margaret Valenzuela, Alice Nakatsu Arredondo, Henry Arredondo, Gail Aguilar, and Jesse Valenzuela. (Left, courtesy Sue and Bob Enright.)

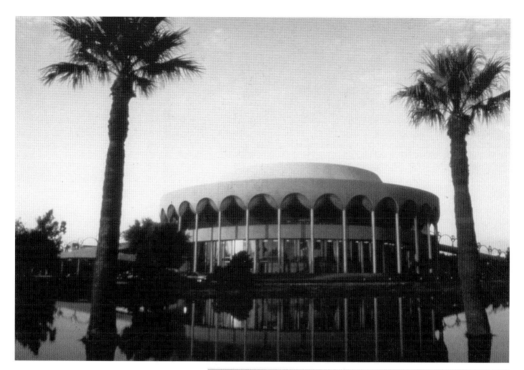

University-Maker

The 1964 Grady Gammage Memorial Auditorium is an iconic Tempe building, named for the Arizona State president (1933–1959) who led the statewide ballot initiative to make the college into a university. The campaign and election were so exciting and competitive—as many near Tucson's University of Arizona preferred there be no other state university—that most Tempeans alive at the time recall it as the single most memorable event in town, if not the state. The victory was a real game-changer in Tempe and Arizona. Grady and his wife, Kathryn, were involved citizens and veritable royalty—regularly hosting local and national dignitaries— such that local broadcasts were interrupted to announce the birth of their son Grady Jr., pictured with them. Grady Sr. died in 1959, before the Frank Lloyd Wright–designed building was completed. (Above, courtesy of Gary Krahenbuhl.)

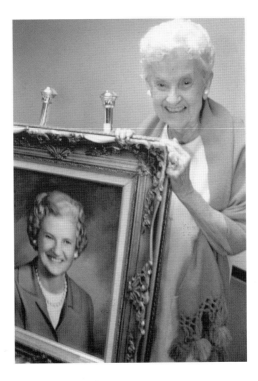

Committed Caring

Kathryn "Kay" Gammage married Grady Gammage in 1949 and immersed herself in college-related activities, including enlisting the Faculty Wives Club to set up signing booths at local shopping malls and going door-to-door to collect names for the ballot initiative to make Arizona State College into Arizona State University. The final vote on Proposition 200 was a landslide in favor of the name change—101,881 for, 51,471 against—and the first time in national history that a university had been named under such circumstances.

After Grady died, Kay continued to be active in the community and on behalf of the university. For instance, she cared about women's issues on campus and engaged in public-relations work and fundraising for ASU for 27 more years, becoming the first fulltime community-relations employee. Given that Kay secured most of the early private gifts and grants to the university, she can be considered the founder of what is known today as the ASU Foundation. To this day, students benefit from her efforts, such as the Grady and Kathryn Gammage Scholarship Program, which launched in 1984. ASU acknowledged Kay's many contributions by selecting her as a recipient of an honorary degree in 1985.

In 1989, Kay Gammage moved into Friendship Village and continued to serve on the board that helped the retirement community succeed. She died in 1997. The idea for the village came from citizen meetings during Tempe's US bicentennial celebration in 1976, when the Horizon Committee was formed to consider the city's future, with an eye to discover needs and work to meet them before they became a problem. Members of the group realized that as Tempe's growing population aged, many might like to stay in their beloved town near current friends and Tempe could use a retirement community with a nursing home component.

Retired General Motors executive Willis Turner, retired Tempe rancher Faybert Martin, and retired nursing home administrator Larry Dyball worked together, ultimately securing about 50 acres from Lula Mae Hudson and involving others like Kay on the board. In 1980, the first of the roughly 800, on average, residents across the different levels of care—from total independence to careful supervision units—moved into Friendship Village. The residents are active inside and outside the village in many ways, including the Knit Pickers group, which knits caps for newborns at the children's hospital next door. (Courtesy of Grady Gammage Jr.)

Archiving Legacies

The roles a university plays in a community cannot be overestimated, but a glimpse can be seen in considering the work of archivists who document and preserve history, near and far, when people donate their documents, photographs, and objects to museums and archives. Tempean Alfred Thomas Jr. graduated from ASU in 1938 when it was called Arizona State Teachers College, and received his master's degree in 1940. He then worked at the institution his entire life, holding many roles, primarily serving as registrar and director of admissions. Thomas (in framed photo) began the ASU's archives in 1972 after unofficially pulling together materials for some years before.

Thomas had the foresight to know that preserving various important documents—like Grady Gammage's presidential records (pictured in the background)—would be a rich source of history and context that informs the university's decisions today. Archivists collect, among other things, records produced by particular institutions and also noteworthy personal papers—usually work output—of interest to researchers. A fun example of this is the material donated by retired ASU professor (1961–1991) Nicholas Salerno, who acquired many pop-culture artifacts, including an extensive Star Wars collection with rare items, via his studies and his television show on cinema classics.

While museums and archives collect many of the same kinds of materials, museums are more focused on material objects of general interest and public education. Thus, as his life wound down, Thomas was careful to donate many of his personal papers and photographs to both ASU Archives and the Tempe History Museum to ensure their safety and accessibility. After Thomas retired in 1983, ASU's archives grew under the guidance of Edward Oetting (left), who served as university archivist from 1983 to 1996 and helped the unit move toward computerization, as there were only four typewriters there when he arrived.

ASU continues to attract important institutional archives and personal papers under the leadership of Robert Spindler (right), who has served as university archivist since 1996. Much of his work today involves digitizing paper, audio, and visual materials, preserving digital materials, and placing them on the Internet for public access. (Author's collection.)

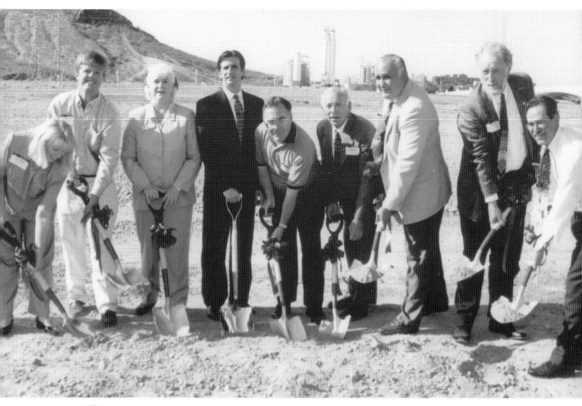

Changing Landscapes

Like some of his predecessors, ASU president Michael Crow changed the face of Tempe. His decisions have global reach, as he remakes ASU into the "New American University." Under his leadership, since 2002, student enrollment has ballooned. Shifting demographics and a recent partnership with Starbucks subsidizing ASU online degrees for its employees promise to fuel that growth. Crow's initiatives to solve national problems locally reinvigorated a tradition of community embeddedness and responsiveness that was first envisioned by the territorial school founders. Currently, ASU is developing 330 acres at the north end of Tempe near the stadium and river bottom. ASU was involved in the original Rio Salado Project, which created Tempe Town Lake, as the idea generated from a 1966 class project. Mayor Giuliano (above, fourth from left) breaks ground for that gigantic shift in Tempe's landscape. (Above, courtesy of Neil Giuliano; left, courtesy of ASU Office of the President.)

33

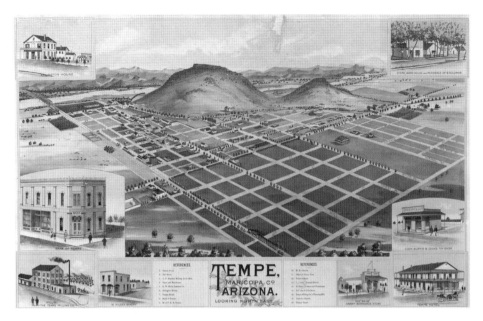

Change Happens

More people than can be named or counted contributed to building Tempe on many different levels, creating positive reputations for themselves, the city, and the institutions they helped create—which are legendary in their own right. The 1888 Dyer map above shows the grid-like streets of early Tempe remain, but much has changed. The agricultural land is gone. The single building in the long strip of land on the right is the Territorial Normal School—ASU's first small building on its original 20 acres. Now ASU covers over 600 acres in Tempe, with more under development. Below is a similar view of Tempe around 1965, with the newly opened Grady Gammage Memorial Auditorium in the foreground. That iconic building remains, but the campus and Tempe continue to change around it, including more energy-wise choices like solar panels.

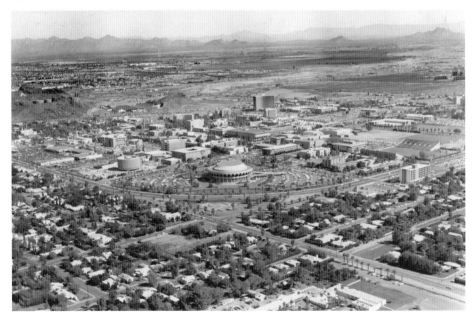

CHAPTER TWO

To Protect and to Serve

Territorial settlers fought tough living conditions to start and develop their lives. Whether they had a little or a lot, there was something to protect and plenty of ways they could serve each other. Charles Trumbull Hayden and folks like the Sotelos and Millers helped set the tone with kindness and generosity. While some disagreements or prejudices may have existed, generally folks had to pull together to forward their personal and community goals. It was the next generations of Tempeans, whether native-born or transplants from elsewhere, who needed to carry the torch of collaboration and build upon what others had achieved, turning ranches and farms into a modern, vibrant city.

Population demographics change for many reasons. Sometimes populations decrease due to epidemics—like the 1918 influenza epidemic—or to citizens leaving to fight in wars. Tempe experienced a huge influx when servicemen who had come to the valley for training at military bases returned after World War II to the fine weather and big open spaces to pursue their lives and usually their education at Arizona State College. Grady Gammage Sr., president of ASC/ASU at the time, had been predicting this influx throughout the war, hoping others would join him in preparations. He was right. From 1946 to 1950, enrollment grew from 553 to 4,094, with two-thirds of the new students being male and most of them veterans. Tempe began a growth spurt that continues to this day.

While wars have their place and victories are celebrated, war also feeds fears and prejudices, like when Japanese families—many American citizens—faced restrictions or were forced into internment camps by Executive Order 9066. For others, war reduced some prejudices, as those serving in the armed forces fought side-by-side with people of different backgrounds or skin colors, trusting each other with their lives. For many it underscored that, at the root, people have much in common—including a sense of humanity—despite cultural, socioeconomic, or racial differences.

Serving in the military is a traditional way to protect and serve one's community and nation, and Tempe has had its share of war heroes. Law-enforcement officers, firefighters, and emergency personnel also help protect people and property every day, as well as provide a sense of security by just knowing they will come when called. The police and fire departments have grown as the city has. For instance, law enforcement in town used to be a single constable or a marshal or two. By 2014, the Tempe Police Department had grown, making wise use of a budget of over $79 million a year.

But there are other ways to protect a community beyond being a sworn officer. Every day, people take actions that help protect the past, present, and future of the community, from parents who instill family values to educators who inspire and instruct, and all manner of businesspeople, public servants, and citizens who make thoughtful choices and realize there is more to life than serving one's self.

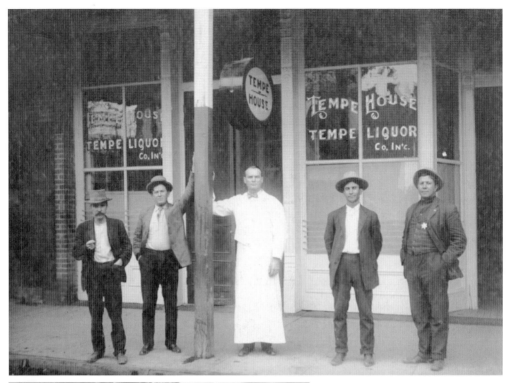

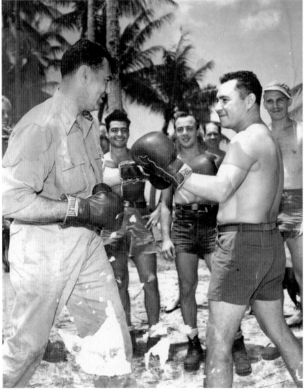

Cresencio Sigala

In the early days, matters of law and order were often carried out by a constable such as Cresencio "Chris" Sigala, above right, who was elected in 1904. Born in La Paz, Baja California, in 1874, Sigala served the growing town and territory in many ways, including 20 years of service in the National Guard, which took him elsewhere in the country. In Tempe, he served as a butcher and grocer, truant officer, deputy sheriff, assistant fire chief, and typesetter for the *Tempe Daily News*. He attended the Territorial Normal School—now ASU—and played football there, helping win the first victory over Tucson's University of Arizona in 1899. Later in life, Sigala helped to train and coach boxers as they passed through the valley. His son Charles, at right in the image on the left, spars with Jack Dempsey around 1940.

La Liga Protectora Latina

Sigala also helped protect others as a 1914 founding member of La Liga Protectora Latina (the Latin Protective League), a mutual-aid society in Arizona to help members deal financially with unexpected health, accident, and death expenses, as well as with education and social assistance. Supportive of labor and civil rights for immigrants, the Tempe lodge was the first in the state and also served as an employment bureau for members.

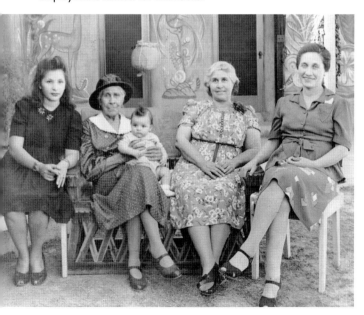

Elias Family

Hardworking families like Vincent Elias's were the norm. In the 1880s, he built a one-room house for his wife, Inez, and they raised eight children there. A dozen of their grandsons and 17 great-grandsons served in the US armed forces. The house, which still stands, grew to four rooms. Beginning in 1927, their daughter Irene and her husband, Ray Rodriguez, a truck driver for 45 years, raised their seven children there. Five generations of Elias/Roderiguez women are shown here.

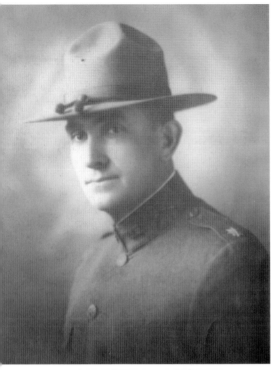

Carl Trumbull Hayden

Carl T. Hayden, born in 1877 to Hayden's Ferry/Tempe founder Charles Trumbull Hayden, served broadly, including in the Territorial National Guard with Cresencio "Chris" Sigala and as a Maricopa County sheriff from 1906 to 1912, making the rounds at saloons when horse theft was still the most common crime. When the National Sheriffs' Association created an award for the most meritorious act each year—"The Sheriff Andy Griffith Lawman's Award" after the actor (below left) and fictional TV sheriff—Hayden (below right) was recognized in 1965. After Arizona's 1912 statehood, Hayden was elected state representative for eight terms until 1927, then as senator until 1969, the first senator to serve seven terms. Serving in Congress 56 consecutive years—the record at the time of his death—he was integral to meaningful legislation, including policy regarding reclamation, power, water, and the highway system.

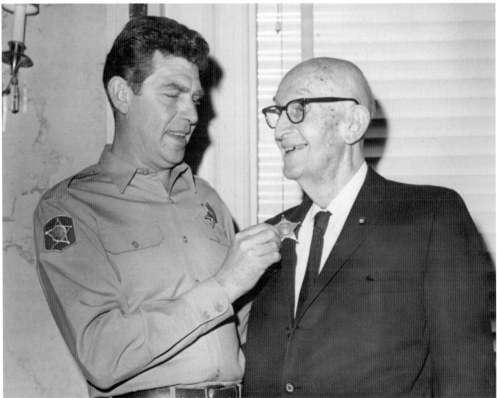

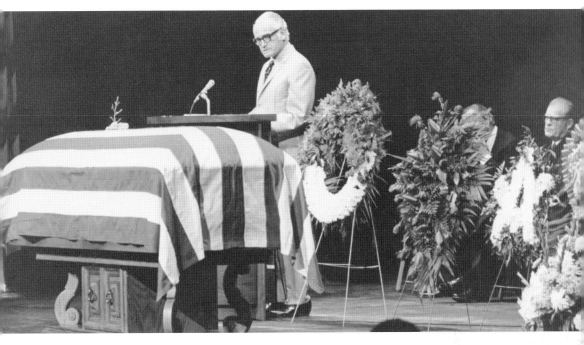

State Funeral

Like his father, Carl Hayden was well loved by those across all walks of life and from both sides of the political aisle. His death in 1972 was grieved, and the funeral was an elaborate affair with such dignitaries as Sen. Barry Goldwater (above) and Pres. Lyndon B. Johnson delivering eulogies at Gammage Auditorium. Hayden's nephew Hayden C. Hayden wisely opted to have Arizona Highway Patrol officers as pallbearers, led by Tempe mortician Lawrence Carr (below), so as not to accidentally slight people by choosing among many family friends and important colleagues. Local police officers Bob Enright and Mike Wilkins both remember having special duties in guiding and protecting the dignitaries on their visit to town for this sad event honoring a life well lived in the service of others.

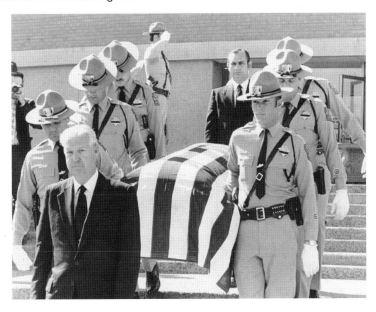

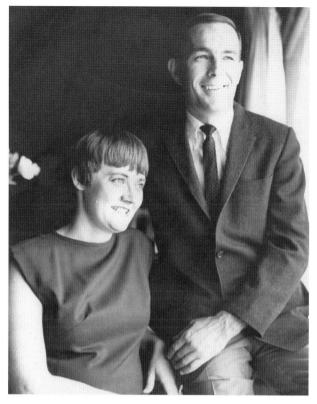

Community Contributors

The police department that helped out at Hayden's funeral has changed over the years, and joining the force was not always as involved as it is today. Tempe native Robert "Bob" Enright's interest in joining grew when he rode along with Benny Hinds and helped at the department at night. At 21, in 1959, he passed a 10-question test and was given two shirt patches and minimal on-the-job training as he joined the other 12 or so people on the force. He earned $325 a month for a six-day work week and bought his own uniforms and weapons.

As a lieutenant, he greatly contributed to formalizing training, planning, and research as the department and city grew. He was instrumental in fighting discrimination by promoting equal opportunity in promotion and human-resource practices and helped secure the first federal grants for the department. Bob retired in 1981 and still lives in Tempe with his wife, Sue, pictured above in 1970.

The 1956 Tempe High graduates contributed much to their community. Sue remembers her civic involvement beginning in her sophomore year when she helped head the Tempe's Teens Against Polio Committee, a natural choice given her father, Dr. Marcus "Mark" Westervelt's, efforts inoculating against polio. The couple's resume includes helping establish the Tempe Historical Society—Bob was the first elected president—which ultimately led to the city-administered Tempe History Museum, which will be enjoyed for generations to come. Before the initial space requested for the museum was secured, some of the artifacts for the museum were stored in the couple's home. Since then, Sue helped with many displays and helped get the Hispanic community involved in the museum. It is no wonder that the couple was in charge of Tempe's centennial celebration in 1971 (see page 117).

Likewise, Sue helped organize many reunions for Tempe High and Our Lady of Mount Carmel, where she learned from nuns of the Sisters of Charity of the Blessed Virgin Mary order. That likely contributed to her later serving for 22 years as part-time librarian at St. Daniel the Prophet Catholic School in nearby Scottsdale. The Enrights are good examples of citizens who protect and serve along many different dimensions beyond their careers. (Courtesy of Sue and Bob Enright.)

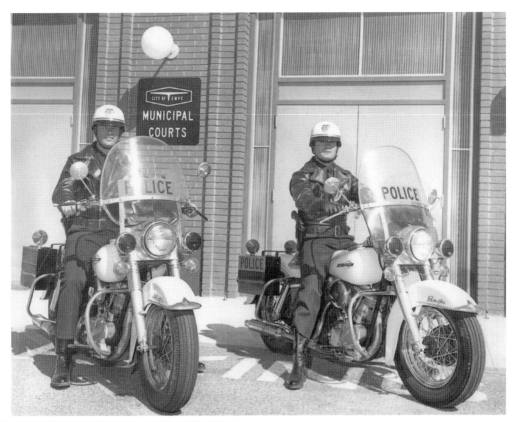

Victor Michael "Mike" Wilkins

It was not until 1969 that valley police departments sent cadets to a police academy, so when Mike Wilkins joined the other 21 police officers in Tempe in 1964, his entry point was as a dispatcher for three months before becoming a patrolman and later a detective. While motorcycles were used earlier to help enforce traffic laws, it was under Mike's leadership (above left in 1971 with John Stinnett) that the squad grew to 10 officers by 1973. By 2014, the traffic bureau had 32 of the 491 employees—70 percent sworn and 30 percent civilian—in the department. In that year, officers responded to 84,707 calls for service, not counting the 67,091 proactive officer-generated calls. Mike retired from Tempe's force in 1981 and from police work in 1994. Elected justice of the peace in 1999, Wilkins (left, with John Orr) served in that capacity full-time until 2006 and part-time until 2014. (Above, courtesy of Jerry Brock; left, courtesy of Mike Wilkins.)

Animal Officers

Other species protect and serve, too. Since 1979, dogs trained for patrol, suspect apprehension, and narcotics detection might lose their lives in service like the seven marshals, officers, and firefighters since 1919. K-9 Murph—who had conducted 708 total searches and helped arrest 45 felons—was shot in 1986 confronting a kidnapper. Dogs like Eris (pictured) and the horses in the mounted unit, started in 1974, are valuable and loved members of the team.

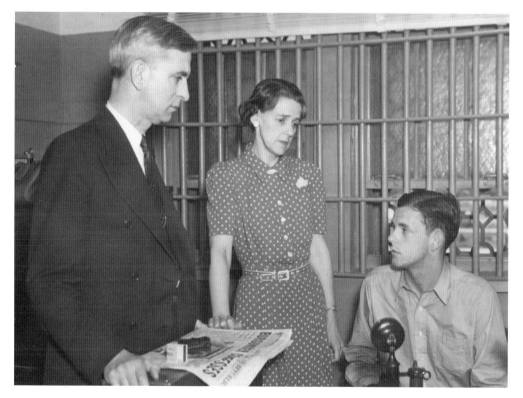

Notorious Criminal

Robert Burgunder Jr., a student at ASTC/ASU, earned national attention after attempting the perfect murder—an obsession of his, even preparing a speech on it. On May 1, 1939, he test-drove two car salesmen to the desert, murdered them, and headed east. A national manhunt found him in Tennessee a week later, returning him to Arizona for a trial in which his lawyer father, above with his son and wife, defended him to no avail. Burgunder died by cyanide gas in August 1940.

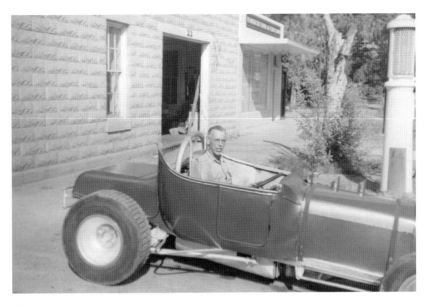

Carl Spain

Whenever a fire starts, the Tempe Fire Department stands ready to respond. Early fires included Hayden's flour mill in 1917 (and later in 2002) and the Tempe Hotel (where the Casa Loma stands) in 1894, back when using bucket brigades with water from ditches was common in the volunteer-only department. The year 1957 marks the first paid fulltime fireman, Wally Filger, who was hired to get the truck to fires. The first professional department, with 11 firefighters, began under William Hanna in 1961. Mechanic Carl Spain, pictured above in 1947 in a 1925 Model T Roadster and below left with volunteer firefighter and mortician Lawrence Carr, was a well loved early fire chief from 1937 to 1953. Carl knew about fire from his father, E.P. "Pompei" Spain—one of Tempe's first blacksmiths and volunteer firemen. (Above, courtesy of James Albert Kitts.)

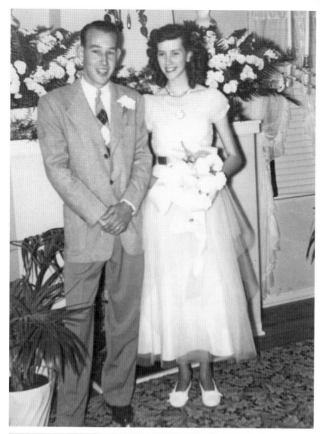

Ralph and Shirley Blanton
Ralph Blanton won the first Tempe Fireman of the Year award in 1963, in part due to saving the life of an eight-day-old baby in 1962. First a volunteer, Blanton was hired as one of the first professional firefighters, and in 1981 he was the last of the original firefighters to retire. The slim department he knew grew to include teams prepared to respond to hazardous-materials emergencies, especially unusual or complex rescue incidents, medical emergencies, crisis avoidance, and fire investigation in a department that exceeded 182 employees and responded to over 22,700 calls in 2014. Ralph and Shirley (top, on their wedding day in 1950) earned a mayoral declaration, the Ralph and Shirley Blanton Day, in 2007. Shirley is seen at bottom in 2015 with fellow local history writer Santos C. Vega. Shirley wrote a comprehensive history of the Tempe fire department, as well as a book on Tempe itself, and Dr. Vega wrote *Mexicans in Tempe* and a history of Tempe St. Luke's Hospital. (Top, courtesy of Shirley Blanton; bottom, author's collection.)

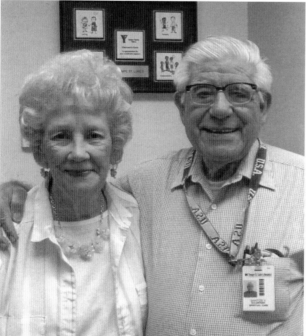

Plants and Animals Matter

Land and animals need protection, too, and Josephine Guess Birchett was Tempe's resident "Bird Lady." Folks brought her wounded birds for care, and she frequently spoke at civic luncheons and classrooms. Her home was a federally recognized bird sanctuary from 1940 to 1970, and she banded some 5,000 birds for researchers. Arriving in Tempe in 1903, she was an active citizen and selected as Tempe's centennial queen in 1971. Those birds surely appreciated many Tempe trees, and Vic Palmer (below, left), Tempe's first parks and recreation director, helped Boy Scouts plant at least one. Vic's daughter Sandy met her husband-to-be, Joe Spracale, at Tempe Beach Park, where he was both a lifeguard and pool manager.

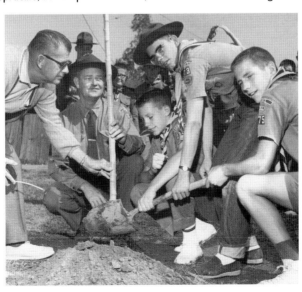

Arthur John Matthews

Helping the community extends beyond hometown public service, as military personnel often protect home and hearth by leaving the community, even while some of their training might be in town. For instance, early military preparation occurred in the Normal School Cadet Company. A few cadets are seen behind (from left to right) Frederick Irish, Gen. John J. Pershing, and principal and president Arthur John Matthews by the fountain in front of Old Main on campus when Pershing—the commanding general of the American Expeditionary Force—visited the fledging campus around 1920.

Irish was in charge of the drills that helped students perform as a company of soldiers, and the cadets won awards in competitive field exercises. Territorial Normal School cadets even had the honor of guarding President McKinley during his visit to Phoenix in 1901. Over the years, 106 of Irish's cadets joined the armed forces. In 1926, the school ceased military exercises to begin again in the 1940s as the ROTC, which continues on ASU's campus to this day.

Matthews led the school from 1900—through two name changes—retiring in 1930 when the school was called Arizona State Teachers College. Among other things, he raised the entrance standards, improved accreditation, and built 18 campus buildings, including five dormitories and the Blome Training School—later to be replaced by the Payne Training School. An avid gardener, Matthews beautified the expanding campus, planting countless flowers, 1,512 shrubs, 5,738 feet of hedges, and 1,478 trees of 57 kinds, including lining Normal Avenue with palm trees that grew up to be what is now the iconic Palm Walk on ASU's campus after neighborhood streets became malls.

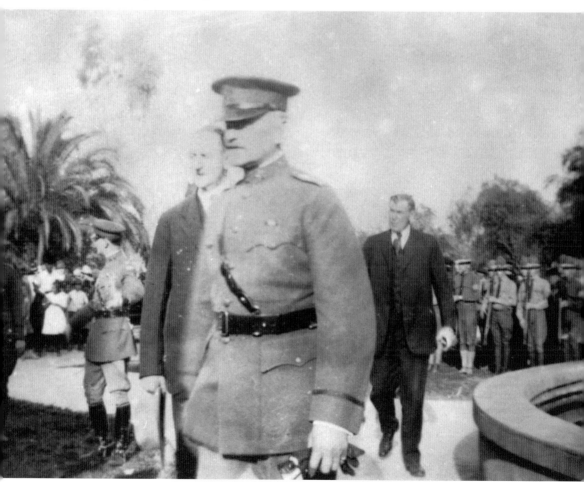

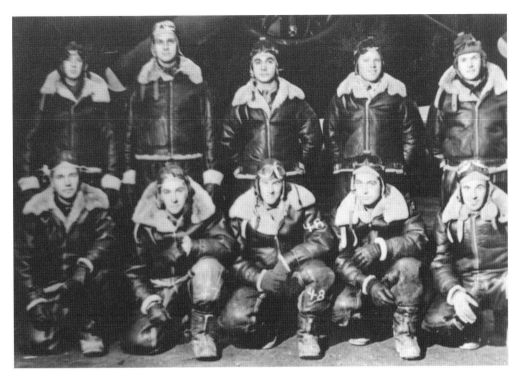

Selfless Sacrifice

Todd "Arizona" Harris, second from right in back row, served in the Army Air Force. In 1943, his B-17 was shot down over the English Channel. Enemy fighter planes continued to shoot as the crew parachuted into the water. Harris never left his turret gun as the B-17 sank, firing back to protect his friends from the German guns. He was posthumously honored with the Distinguished Service Cross.

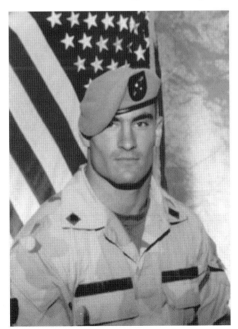

Modern-Day Hero

ASU alum Pat Tillman set aside an NFL football career with the Arizona Cardinals to serve his country after the September 11, 2001, terrorist attacks. An Army Ranger, he died at 27 in 2004 serving in Afghanistan, where a USO center now stands in his name. He inspired others—events honoring him raise funds for veterans' scholarships, and his jerseys continue to outsell others. (Courtesy of the Pat Tillman Foundation.)

Gov. J. Howard Pyle

Another Tempean who made a nationwide impact protecting others was John Howard Pyle. As a boy in Nebraska, he realized he had a good voice while singing in church. That voice went on to serve him well. He began singing before he arrived in Tempe in 1925 and was an on-air soloist and radio announcer in Arizona, among many other jobs he took around Tempe—including timekeeper for the Southern Pacific Railroad. His journalism skills and voice led to his being the first radio war correspondent in World War II to land in Japan with the ground forces, covering the Japanese surrender for all four US radio networks at the time. He is fondly remembered for his Easter Sunday radio broadcasts from the Grand Canyon, as a television spokesperson for Monti's La Casa Vieja restaurant, and as the voice of *Arizona Highlights* statewide.

In 1950, with Barry Goldwater as his campaign manager, Pyle was elected Arizona's ninth governor for two terms; the first Republican in 32 years, the close-race win is credited with restoring two-party politics in the state. Pyle continued to serve the public after he left that office in 1955, including four years as a deputy assistant for State-Federal Relations in Washington, DC. When General Eisenhower became president, he appointed Pyle to assist him in coordinating ongoing safety campaigns to reduce unintentional injuries, as both men had seen many such accidents in the war. Pyle served two terms in that role and then 15 years as president of the National Safety Council, including chairing the Occupational Safety and Health Administration's National Advisory Committee.

He retired in 1974 and kept his thumb to the pulse of events in various ways, including writing a column for the paper, serving as a Tempe city councilman, and speaking at fundraisers. While he was respected nationwide—earning honorary degrees from several universities, including ASU—his roots were in Tempe, where his wife, Lucille Hanna, and his daughters, Mary Lou and Virginia (above), were born. The Pyle Adult Recreation Center is named in their honor. During the difficult times of World War II, when discrimination against Asian American families was common, Christine Kajikawa Wilkinson remembers the support Pyle offered her family when, for example, Pyle courageously said in one of his broadcasts, "Margaret and Bill Kajikawa, if you're listening to this or wherever you might be, you have friends."

Kajikawa Family

Pyle was referring to longtime residents Margaret and William "Bill" Kajikawa (above). Bill graduated from Arizona State in 1937 and stayed on in athletics from 1937 to 1978 as coach for basketball and baseball and as assistant football coach to Frank Kush. ASU named a practice football field after him and awarded him the 2004 Lifetime Achievement Award. Bill proudly served his country in World War II, with distinction, in the Army's 442nd Regimental Combat Team, an all–Japanese American and all-volunteer unit. He and Margaret, who is frequently mentioned as being "involved in everything in Tempe," earned many civic awards. Their daughter Dr. Christine Kajikawa Wilkinson (left), an ASU Sun Devil herself, serves ASU with the same vigor, currently as senior vice president and secretary of the university as well as president of the ASU Alumni Association. (Left, courtesy University Archives Photographs, Arizona State University Libraries.)

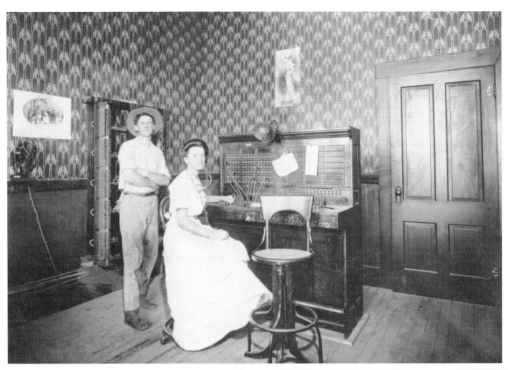

Helpful Citizens

Not all who serve put their lives in danger. Estelle Craig Hackett served as Tempe's first telephone operator in a comfortable second-floor room of the Laird & Dines building (above). The Craig and Hackett families were longtime Tempe families, and the Hackett House is the oldest fired redbrick building in Tempe and the site of its first bakery. That historic building now houses the Tempe Sister Cities program, started in 1973 by Jane and Richard "Dick" Neuheisel, seen at right in 1991 when they were honored with the Sister Cities Garden named after them at Kiwanis Park. So far, Tempe has 10 sister cities worldwide—in Macedonia, New Zealand, Germany, China, Mali, France, Ireland, Ecuador, Peru, and Sweden—and serves by building a positive global community with its educational exchange and cultural-awareness programs. The Neuheisels' son Rick is a television football analyst.

First Voter-Elected Mayor

Before Rudy Campbell (above at left singing at an event) became Tempe's mayor in 1966, mayors were appointed from amongst the city council members. Rudy's connection to Tempe runs deep, as his parents, Napoleon Bonaparte and Jodie Campbell, and his sister Imogene were killed on the railroad tracks on Rural Road between Broadway Road and Apache Boulevard in 1942, leaving him at the age of 19 to raise his five-year-old brother, Doug, alone at first, until his bride, Greta, joined the family in 1943. When he later served on the Tempe City Council—and then became mayor—he acted swiftly to get railroad crossings more safely marked.

It was on his watch that the Tempe Historical Society began, at the request of newspaperman Max Connolly, who Campbell put in charge of making it happen. Though Oklahoma-born Campbell was raised dirt poor—his family suffered through the Great Depression and the Dust Bowl—and he never went to college, his friendly ways, solid values, strong work ethic, and willingness to learn anything led to his appointment to important boards all over the state. Among them were the board of transportation and two eight-year terms on the Arizona Board of Regents, 1974–1982 and 1992–2000, where he advocated in the interest of education with vigor and wisdom, realizing its benefits even though he never went to college himself. He credits his mother for his finishing high school, as she made sure he enrolled in school no matter where the family lived, as sharecroppers in Oklahoma or following the fields as migrant workers after heading to the West.

As mayor, Campbell persuaded others to help revitalize the downtown area by laying the groundwork for building the new city hall and police station there, while putting the library farther south where the population was growing. His legacy also includes working with an ASU class to help envision the design for the Rio Salado Project by the river, leading to Tempe Town Lake, and he was involved in creating the ASU Research Park after ASU's experimental farm was closed in 1981. As chairman of the Sun Angel Board in 1988, he helped create the ASU Karsten Golf Course. Rudy still lives in Tempe and is seen in town at events for organizations such as the Boys and Girls Clubs. His heart of gold is still beating strong as he approaches his mid-90s.

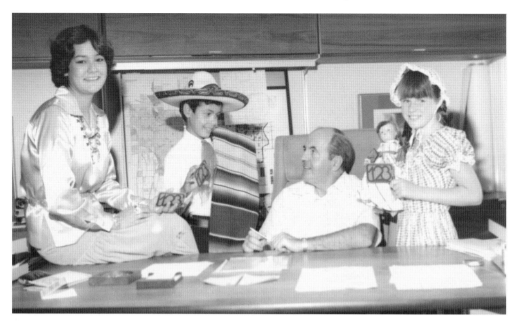

Beloved City Manager
Rudy Campbell is proud of bringing longtime city manager Ken McDonald to Tempe's team during one of Tempe's biggest growth spurts, from 1968 to 1983. McDonald, pictured above in 1977 with students Linda Dodge (left), Roberto Regalado, and Laurie Enright representing the Native American, Hispanic, and pioneer influences on Tempe's heritage, inspired a Tempe golf course named after him to honor his effectiveness and community spirit.

Neil Giuliano
ASU alum Neil Giuliano, Tempe mayor from 1994 to 2004, easily won a 2001 recall election mounted by opponents to his homosexuality. Tempe was named an All-America City under his leadership, and among other important things, he established the city's annual Diversity Award. Since leaving office, he has become a nationally known gay-rights activist—including serving as CEO of the San Francisco AIDS Foundation—and authored *The Campaign Within: A Mayor's Private Journey to Public Leadership*. In 2015, Giuliano was recruited to be president and CEO of Greater Phoenix Leadership, a 40-year-old organization that focuses on civic improvement initiatives. (Courtesy of Neil Giuliano.)

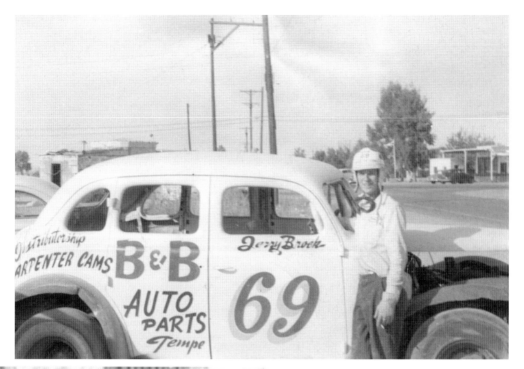

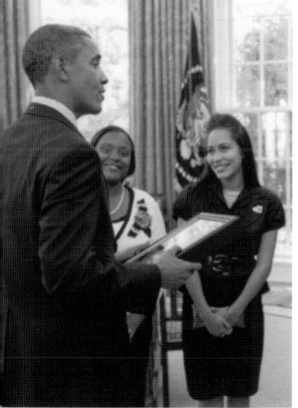

Philanthropic Businessman Jerry Brock

Local businesses help with more than offering goods and services. The family business Brock Supply—a national wholesale automobile parts supplier since 1960—thrives in Tempe. Jerry Brock, a music and racecar enthusiast, is seen at age 15 with his 1937 Ford in 1955, the same year he got his NASCAR driver's license. Brock won the 2014 Spirit of Tempe Award from the Tempe Chamber of Commerce for his generosity to organizations that help others succeed, including the East Valley Boys and Girls Club. (Courtesy of Jerry Brock.)

Ramonia "Mona" Dixon

Boys and Girls Club donations like Jerry Brock's help folks like Mona Dixon (center) who overcame homelessness. Mona was chosen as the organization's 2010–2011 National Youth of the Year, earning generous scholarships and meetings with luminaries such as President Obama and singer Ashanti, both shown here, during her year as spokesperson. The Tempe High graduate went on to graduate from Barrett, the Honors College at ASU, in 2014 and to pursue her master's degree. (Courtesy of Mona Dixon.)

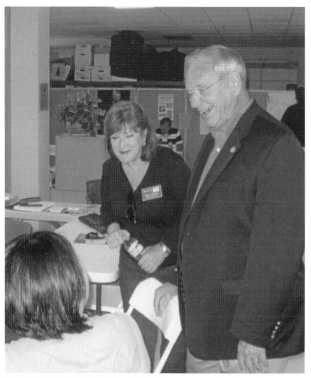

Katherine "Kate" Hanley
Jerry Brock also supports the Tempe Community Council, led since 1989 by Kate Hanley (center), pictured here with Harry Mitchell, who started the council in 1972. The nonpartisan council, which is housed in the historic home of Gov. B.B. Moeur, works with the community to incubate human-service programs that help stabilize people in need whether they be young, old, pregnant, or homeless. They then help the programs find their own funding so they are self-sustaining after the start-up help. (Courtesy of Tempe Community Council.)

Congressman Harry Mitchell
The Harry E. Mitchell Municipal Complex—city hall—honors one of Tempe's favorite native sons and 28-year American government and economics teacher. Harry (pictured here and above with Kate Hanley) from early on had a smile that won friends, and his 1958 Tempe High School classmates predicted his political success in yearbook inscriptions. Emphasizing straight talk and bipartisanship, he served broadly, moving from city council (1970–1978), to mayor (1978–1994), to Arizona Senate (1999–2007), and ending with the US House of Representatives (2007–2011). (Courtesy of Harry Mitchell.)

Mitchell Legacy

Politics runs in the family; Harry's grandfather William W. Mitchell Sr. moved to the territory in 1910, published the *Mesa Free Press*, and served in the Arizona House in the 13th, 15th, and 16th legislatures representing Phoenix, and the 22nd and 23rd for Tempe. Mitchell Sr. would be proud of grandson Harry's achievements, especially that he cosponsored the 21st Century G.I. Bill to help veterans. In 2012, Mark Mitchell—Harry's son—became Tempe's mayor. Above, Mark (left) celebrates with his father Harry and Kate Hanley when Harry won the 2012 Don Carlos Humanitarian Award—named after Charles Trumbull Hayden. Below, Harry seats his grandchildren at his swearing-in ceremony as a US Congressman. Given the family history, there is a good chance one of them will enter public service. (Above, courtesy of Tempe Community Council; below, courtesy of Harry Mitchell.)

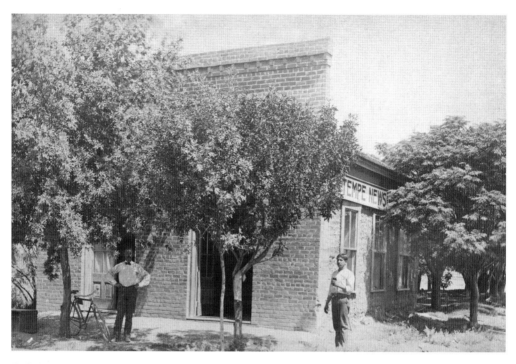

Publisher Curt Miller

Community events and contributions to history must be recorded. Newspapers such as the *Tempe Daily News* contribute to that record. Founder Curt Miller, above left with typesetter Cresencio Sigala, ran the paper until his death in 1943, with Francis "Frank" Connolly taking the reins soon after. Miller wore many hats to serve Tempe and the territory, including as a captain in the Territorial National Guard and stints as postmaster (1893–1897) and mayor (1922–1924).

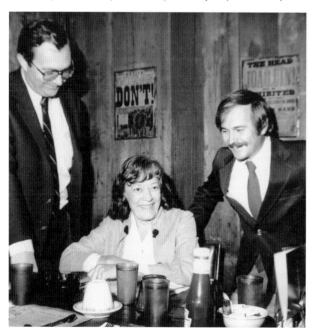

Reporter Peggy Bryant

Peggy Bryant began reporting for *Tempe Daily News* in 1959. In this image, Peggy is being honored in 1985 at a Monti's La Casa Vieja luncheon by publisher Paul Wolfe (left) and managing editor Lawn Griffins for her then 25 years of service, including as editor, to the publication (32 years at that time if including other Arizona papers). While retired, she still contributes, including booking the Tempe History Museum Lunch Time history speaker series.

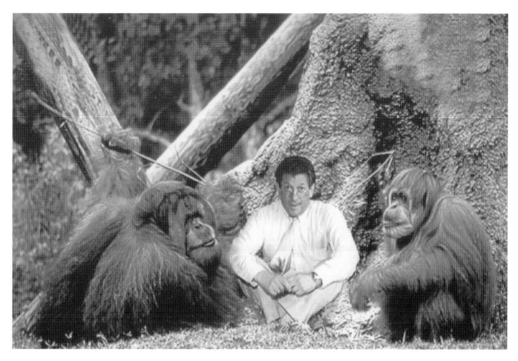

Columnist Vic Linoff
Preservation involves sharing history to honor and learn from the past. Vic Linoff writes columns for local newspapers under the name Jay Mark. While serious about history, Vic's alter ego's playful side is seen at a Phoenix Zoo event offering green-screen photographs with different zoo residents. Linoff won the 2013 Spirit of Tempe Award for, among other things, his 40 years of advocacy efforts on many Tempe initiatives. (Courtesy of Vic Linoff.)

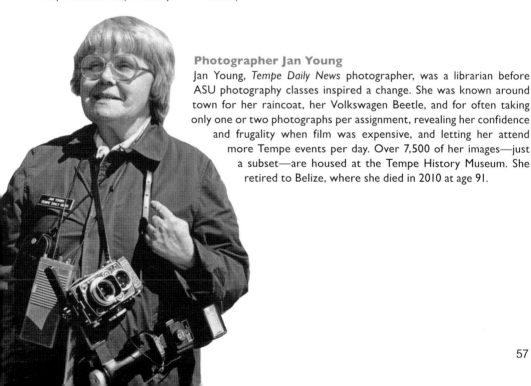

Photographer Jan Young
Jan Young, *Tempe Daily News* photographer, was a librarian before ASU photography classes inspired a change. She was known around town for her raincoat, her Volkswagen Beetle, and for often taking only one or two photographs per assignment, revealing her confidence and frugality when film was expensive, and letting her attend more Tempe events per day. Over 7,500 of her images—just a subset—are housed at the Tempe History Museum. She retired to Belize, where she died in 2010 at age 91.

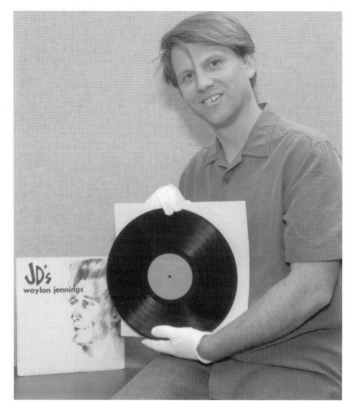

Curator Joshua Roffler

Linoff's efforts involve research at the Tempe History Museum, whose mission includes connecting residents with their community and capturing stories as history continues to be made. Joshua "Josh" Roffler Sr., curator of collections, enjoys that about the work he has been doing with the museum since 2000.

As overseer of 12,000 artifacts and 50,000 photographs, the 1993 McClintock High graduate knows a lot about Tempe and is proud that the 2010 renovation to the building permits flexible, dynamic exhibits that engage visitors. To some, the museum began in 1991, when the Tempe Historical Society—made up of citizens who wisely cared to capture their history—passed their collections over to the city and a fulltime staff charged with preserving and sharing it. To others, the museum began when those same caring citizens, many of them members of the Tempe Old Settlers Association, came together to begin the work.

Above, Roffler holds Waylon Jennings's first album—only 500 first-press recordings and only 1,000 total of that album were made. Jennings was in the house band of Tempe club JD's, where the album was recorded and produced in 1964 by the son of the club's owner. This was the first artifact Roffler acquired in his outreach efforts to over 40 local musicians and venues to compile the popular Tempe Sound exhibit that was mounted in November 2014 for 11 months.

The exhibit made good use of the community room, which allows the museum to offer lectures and concerts and a series of sub-exhibits that enhance the longer-standing ones. The room is available to the public for gatherings and brings a fresh variety of people to the museum on a regular basis. Josh Roffler is a member of a skilled team that includes Brenda Abney (director), Jared Smith (curator of history), Dan Miller (exhibits coordinator), and others, including interns from, for example, ASU's graduate programs in museum studies (a degree that Roffler holds) and public history programs, as well as many helpful volunteers like Dan Thompson—a train enthusiast and master photograph scanner—who has served there since 2002. (Courtesy of Vic Linoff.)

CHAPTER THREE

Service with a Smile

Everyday life provides the opportunity to serve each other in numerous ways, whether as a teacher, postal carrier, friendly neighbor, or shopkeeper. No matter the profession or business, people helping people is a common theme. And product manufacturers, retailers, and service providers, while providing a livelihood for themselves, do much to help make life interesting and easier for their customers.

As with everything else in Tempe, the food scene has changed significantly over the years. Mom-and-pop shops with their unique flavor and style slowly gave way to more and more corporate chains offering their fare. Now the Local First Arizona movement, and similar awareness-raising and advocacy groups, are reminding residents of the benefits of buying local to, among other things, better support the local economy. Thus, while the chain restaurants are still appreciated and are likely here to stay, the Tempe-owned and operated are popular—and some have become chains themselves, like Pita Jungle. For dining at home, independent grocers like Stabler's Market are gone, but farmers markets, or buying shares of vegetables from local farms, are alternatives to corporate stores.

Sometimes a small start becomes a big business, beyond supporting the owners and a handful of employees. For instance, Susan and Barry Brooks brought the smell of fresh cookies to Tempe when they opened Cookies From Home on Mill Avenue in 1981. As chief executive officer, Susan built—via excellent customer service in retail, mail-order, and internet sales—a company selling $12 million in cookies a year. Beyond her normal staff, she regularly hired between 100 and 200 seasonal workers over the holidays, often preferring senior citizens for their proven work ethic and the sense of humor and wisdom they brought with them. They sold in 2010, but the business remains in Tempe as one more reminder of how many Tempeans have had an idea in their kitchen or garage and went on to share it with the world.

Citizens often come together to help each other on that path to success. For instance, the Tempe Chamber of Commerce was founded in 1908 and still serves the community. It has over 700 members—representing over 70,000 people within the member organizations—that range from individual start-ups to large entities like Arizona State University and Honeywell, including nonprofits like United Food Bank and Lost Our Home Pet Foundation. The idea is that no business has to go it alone. Rather, they can work together, and through the chamber they can lobby for legislation and conditions favorable to Tempe businesses, having a larger voice at the local, state, and federal levels as needed. For instance, the Tempe chamber expressed interest in seeing the light rail come through Tempe—which helped reinvigorate a declining Apache Boulevard—just as in the last century, citizens were in favor of a bridge being built in Tempe so all drivers on that growing highway would know Tempe was on the map and maybe stop and stay awhile.

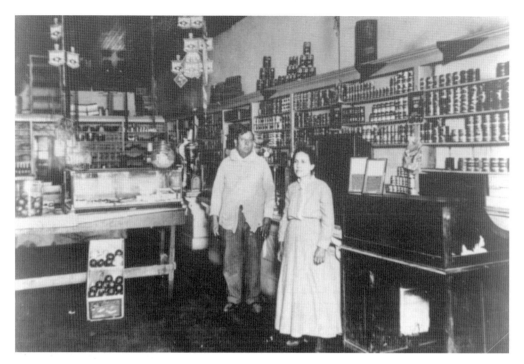

Celaya Family

In the early years, general stores were common. Antonio Celaya, pictured with his wife, Guadalupe Medina, opened a store on Mill Avenue after moving it from the barrio. As a boy, Antonio regularly visited Tempe with Florence priests, serving as an acolyte at the outdoor masses they offered Mexican families before a church was built at the butte. He returned later to settle permanently, first working in Hayden's mill and store before opening his own mercantile.

Ophelia Celaya

The Celayas' eldest daughter, Ophelia, born in 1893, recalls the early family home as comfortable, despite no electricity, gas, or running water, and recalls buying items from Indians who came into town occasionally. The 1912 Tempe High graduate—winner of the first Niels Petersen (see page 111) award for highest GPA—was a clerk stenographer for 40 years for the US Department of Agriculture's Bureau of Entomology and Plant Quarantine, Division of Insect Investigation.

Tempe Old Settlers Association

The Celayas were in the Tempe Old Settlers Association. Formed in the early 1900s, it honors history and builds new relationships at the annual potluck, welcoming folks who lived in Tempe for 30 or more years currently or in their past. City councilmembers and the mayor often attend the event, which includes raffles and brief reminiscences along some theme and sometimes entertainment—like a song or two by the Looney Tooner Kitchen Band, which plays music with things found in the kitchen. The community band—all are welcome—practices at the Pyle Adult Center. This 1970s picnic held in Thane Read's yard includes, from back to front, (left side) Eleanor Cochran, Walter Cochran, Georgia Hampton, Everett Hampton, Grace Painter, and Mabel Ellingson; (right side) Ophelia Celaya, Irene Bishop, Gene Bishop, Lura Aepli, Milton Aepli, and George Boyd (justice of the peace).

Flora Thew

Flora Thew, pictured with her 1944 Tempe Grammar School first grade class, taught many Tempe children in her 48-year career, and an elementary school was named after the well-loved teacher. Thew came to Tempe with her family at age eight in 1898 from Oregon, where her parents, Fannie and Edwin L., had settled after leaving New York. She and her brother Charles were often seen at their father's store on Mill Avenue. (Courtesy of Mae Nell Dare Ehrhardt.)

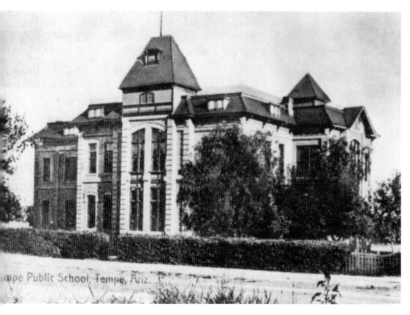

Eighth Street School

The 1891 Eighth Street School replaced the first adobe school in town. In 1925, Adolfo Romo challenged a 1915 policy that segregated Mexican-American children to this school with classes taught solely by student teachers. He won in court, which did help the cause, but segregation of recently arrived or poor families continued to some degree under the "separate but equal" doctrine until the 1940s.

Ira D. Payne

Stanford graduate Ira Payne joined the Territorial Normal School faculty in 1911 to train future teachers until his retirement in 1953. His devotion led to TSTC/ASU naming the 1929 Payne Training School after him, a place that educated many Tempe children until it burned in 1956; fortunately, the Payne Education building on campus remains to honor him. Payne's son, physician William Payne, was a major education advocate in Tempe and the state. (Courtesy of University Archives Photographs, Arizona State University Libraries.)

Cosner Siblings

When popular 1903 Territorial Normal School graduate Elizabeth "Lizzie" Cosner retired in 1939 after 36 years of teaching, ASTC/ASU named the Payne Training School's auditorium in her honor. Lizzie is seen below with other Tempe High teachers—some were also graduates—at a Tempe High School reunion in 1958. From left to right are (first row) Mattie York Meyer, Isabelle McLellan Waterhouse, Bess Barkley, Elizabeth Cosner, Anna Stewart, and Ida Woolf O'Conner; (second row) Emma French Johnston, Gertrude York Christy, Lewis S. Neeb, Lottie Mullen Goodwin, and Ruby Newton Woolf. Elizabeth's brother Clarence Cosner gave land—previously given to him by his employer Dwight Heard—to Tempe's Double Butte Cemetery.

Love at First Sight

Mack Oliver Dumas was Tempe's only dentist from 1933 to 1946, and his wife, Lenore, was the first woman in the state to be elected Coconino County School Superintendent, in 1916, and managed the Casa Loma Hotel on Mill Avenue from 1937 to 1946, at a time when some guests stayed briefly and others called it home. The Casa Loma building now houses Caffe Boa and offices. When Art Bunger first saw their daughter Martha in 1922 at Tempe High, he told friends, "That's the girl I'm going to marry," and he did. They wed in 1943 and had five sons in Tempe, where Art served as city manager from 1953 to 1961 before continuing that career, as well as becoming a land developer, in Prescott. Martha, pictured below in 2012, holds a photograph of Art, who died in 1999. (Both, courtesy Martha Dumas Bunger.)

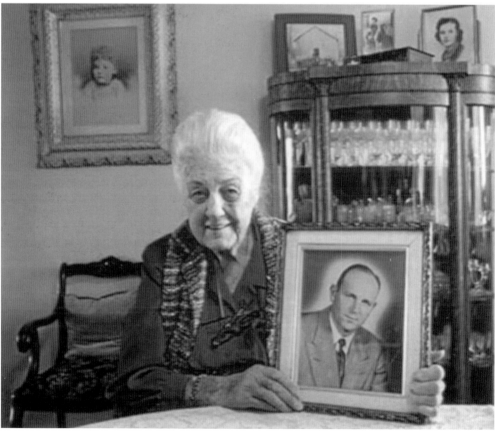

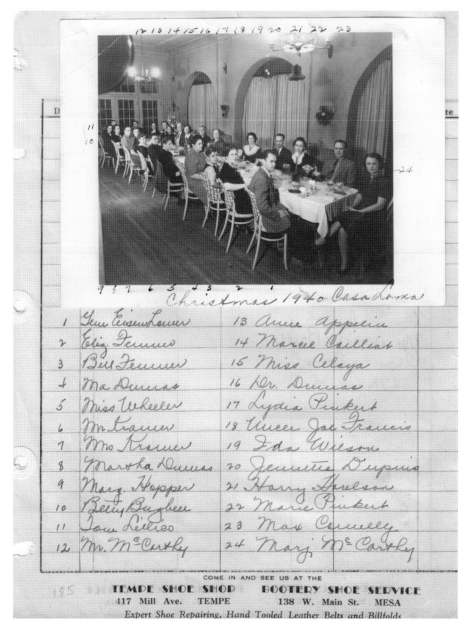

Christmas 1940 Casa Loma

1	Sen Eisenhauer	13	Anne Appelin
2	Eliz. Femmer	14	Marcel Cailliat
3	Bill Femmer	15	Miss Celaya
4	Ma Dumas	16	Dr. Dumas
5	Miss Wheeler	17	Lydia Pinkert
6	Mr. Kramer	18	Uncle Joe Francis
7	Mrs. Kramer	19	Ida Wilson
8	Martha Dumas	20	Jennette Dupuis
9	Mary Hopper	21	Harry Paulson
10	Betty Bagbee	22	Marie Pinkert
11	Tom Lillies	23	Max Connelly
12	Mr. McCarthy	24	Mary McCarthy

Casa Loma

The 1899 Casa Loma replaced an 1894 hotel that burned. Remodels occurred with different owners. Onetime owner William J. Kingsbury, 1897 president of the Farmers and Merchants' Bank of Tempe, cattleman, and 1908 founder of the Kingsbury Senior Assistance Fund to help students complete the Normal School programs, put advertisements in papers nationwide promising "You do not pay if the sun doesn't shine," attracting tourists from across the country. Good weather kept the Casa Loma busy with guests, including Pres. William McKinley and Buffalo Bill Cody. Long-term residents and neighbors often had holiday meals together, and many details of guest visits and current events were logged in guestbook pages like the one pictured. Times change; in the 1970s, the Casa Loma had a bar called the Cave, complete with fake stalactites, frequented by musicians, students, and bikers. (Courtesy of Martha Dumas Bunger.)

Gene and Irene Bishop
Irene Redden was born in Tempe in 1898 when her father, Byron, was a canal manager. In 1919, she married Raygene "Gene" Bishop, both shown here as 1978 museum docents. They had a 10-room guest ranch on Rural Road north of Alameda Drive for about 40 years, where, in 1939, weekly rates were $25 to $35 for a single and $42 to $50 for a double. Closed in 1942, the ranch was subdivided for houses in 1985.

Centennial Celebration
The Bishops, pictured with Sue Enright (right), were active citizens who helped at the Century in the Sun 1971 centennial celebration for the then 25-square-mile city, with fewer than half the residents of today. Some 75,000 visitors attended across the 11-day event—a successful feat of organization under the leadership of Bob and Sue Enright, who coordinated 400 volunteers. (Courtesy of Sue and Bob Enright.)

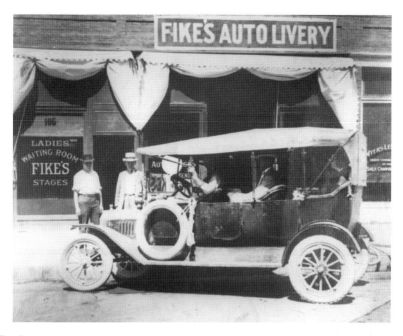

Family Businesses

While horses were common when the Fikes came to the territory in 1898, cars changed the livery business. After horse-drawn stage coaches, Freeman Charles Manuel Fike had a stable of 27 cars that transported people from the east valley to Phoenix and back, as the horses had before, but now as often as every 15 minutes, with less-frequent trips to outlying areas like Globe and Wickenburg. Fike's ran from 1912 to about 1919 when he sold to Union Stage, which, after other mergers, became Greyhound. Fike and his wife, Carrie's, daughter, Mary Alice, married Joseph Wood Pigg in 1934. Their restaurant, pictured below on the northeast corner of University Drive and College Avenue, thrived for six years before they sold it and Joe joined the military during World War II. Mary Alice, a well-respected teacher at valley schools, retired in 1972. They had "the three little Piggs," daughters JoAnne, Mary Lynn, and Jalia, who all graduated from Tempe High.

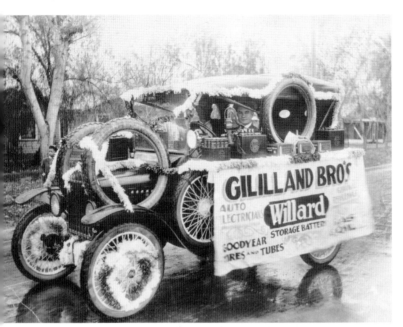

Gililland Automotive

As cars became popular, Clyde Gililland built a garage on Mill Avenue, advertised by his parade car with cotton streamers celebrating the crop's impact on the valley's economy and a key ingredient in Goodyear tires at the time. Gililland Middle School's name honors his 30 years on city council (1930–1960, plus mayor 1960–1961), and his long-term service, including presidencies, to the Tempe Elementary School District 3 Board of Education.

The Bug Line

When John R. Balfour was an undergraduate at ASU in the 1970s, he saw a need and codeveloped the Bug Line, advertiser- and grant-sponsored free student transportation between ASU and Christown/ Spectrum Mall in Phoenix, running from 1974 to 1976. Balfour cared about transportation, environmental issues, and energy efficiency before they were the common topics they are today. His involvement continues, especially in photovoltaic cells that convert light into direct current.

Camera Guru

Another innovator and problem-solver is Joe Wojcich. At age four, he and his parents escaped from East Germany to Western Europe and then New Jersey, where his Ukrainian farmer father had found an immigration sponsor. Joe joined the Air Force at 17 in 1964, and time at Luke Air Force Base brought him back to Arizona after his 1968 discharge. After nearly losing two fingers as a machinist, his photography teacher at Phoenix College helped him get a job at Wilson's Camera for $1.90 an hour stocking shelves in 1972. He soon taught himself to repair cameras and quickly opened his own shop.

Many years and three locations later, he and Tempe Camera Repair Inc. still have the camera tiger by the tail. Beyond the cameras he sold or repaired for ASU students, Wojcich's reputation grew wide as he would take seemingly impossible jobs, finding ways to mate parts from different cameras to make special repairs and adaptations possible. Major organizations like *National Geographic* and the Associated Press took note, sending him lenses by the dozen to adapt to their various needs. Joe also used his machining abilities to help the Air Force out of a jam when they needed 15 special bushings for an irreplaceable piece of equipment—a job too small for most places but big for a little camera store. Joe charged only $25 apiece, later learning others would charge $100 apiece. Never particularly greedy, he has given generously to Tempe and the valley-wide community for years in cash donations or in free rentals of equipment for special projects or programs.

Starting in a tiny space, by 1986 Wojcich had constructed a three-story, 10,000-square-foot building on Roosevelt Street and University Drive, with a 7,000-square-foot image lab next door. Wojcich credits his success to great employees who care about the customers, and in 1994 he was named by the US Small Business Administration the Arizona Small Business Person of the Year. To this day, Wojcich still enjoys solving camera repair challenges and running the business with the help of longtime employees like Susan Smith (since 1979), Bill Lettow (since 1980), and Michael DeLanie (since 1981), and he has been taking some great photographs on his vacations to Asia, for which he has developed a passion. (Courtesy of Joe Wojcich.)

Fulton Family

When Mary Lou Henson met Tempe native Ira A. Fulton as a student at ASC/ASU in the 1950s, she was impressed by his enthusiasm and beautiful teeth, which he managed to keep despite his years playing football, being on the all-state team while at Tempe High and earning a football scholarship to college. Ira wooed her, and they were married for 61 years until her death in 2015. Ira worked hard at different jobs, building businesses like Fulton Homes into successes. Probably Tempe's best known financial philanthropists, they have given to many organizations, including to Brigham Young University and ASU, a combined $230 million at this writing. His Latter-day Saints mother, Myrtle "Myrtie" (below), modeled hard work and generosity at the 1930s hamburger stand in their front yard—Mom's Café, later Sun Devil Café—where she never turned away the needy. (Both, courtesy Fulton Homes.)

Leonard Monti

Leonard Monti, who served on an aircraft carrier in World War II and then as a postwar telegrapher and railway agent, first ran Monti's Grill in Chandler before moving to Tempe in 1954 and opening Monti's La Casa Vieja steakhouse in 1956 in the expanded 14-room version of Charles T. Hayden's former 1871 pioneer home, until recently the oldest continuously occupied structure in the valley. The site of many meetings until it closed in 2014, the current plan is to preserve the historic part of the adobe hacienda—listed in the National Register of Historic Places in 1984—as two high-rise towers emerge around it, once again changing the face of Tempe. In 1995, the city named the trail on Tempe Butte (also known as Hayden Butte or A Mountain) after Leonard, who hiked the mountain daily with friends such as Hayden C. Hayden, Charles T. Hayden's grandson.

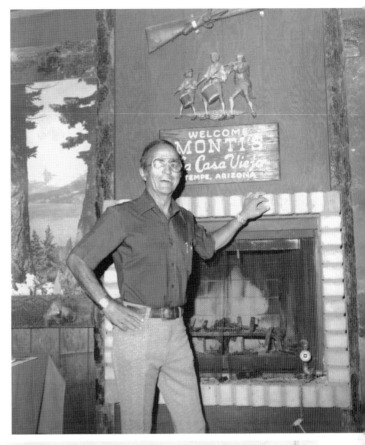

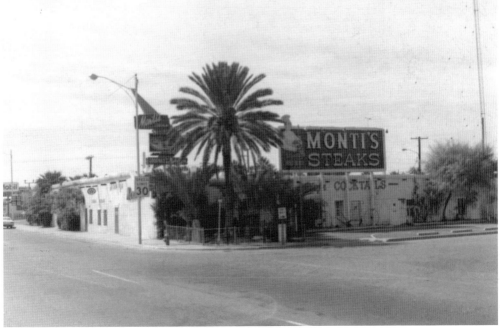

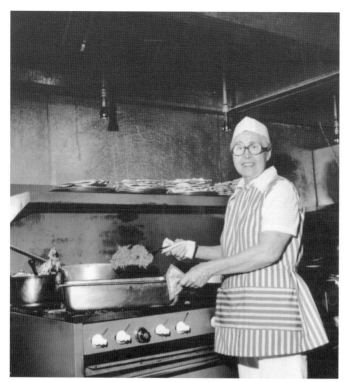

Rosita Keeme

When Rosa Keeme arrived with her parents from Sonora in 1951, she worked in cotton fields and restaurants. Then, with pooled family resources and a banker who trusted her without collateral, she opened her one-room Rosita's Fine Mexican Food in 1963 on Fifth Street, using her mother, Aquila's, recipes. Teaching her five kids and employees that customers come first, the restaurant—on University Drive since 1987 and now run by her grandchildren—thrives.

Social Activist

Gustavo Gutierrez's parents, also from Sonora, were well known as woven hat makers, but his passion was civil rights for those picking the produce people eat, and his efforts included training with Cesar Chavez to help migrant workers. Together with others, like the Mexican American Student Organization on ASU's campus in 1968, Chicanos Por La Causa was born, flourished statewide, and is a model for other organizations nationwide.

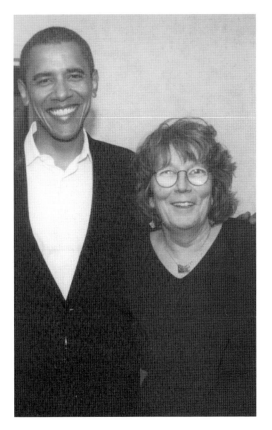

Books Change Lives

Another independent business that keeps thriving is due in part to Gayle Shanks, seen above with Barack Obama, who was visiting the Changing Hands Bookstore for a book-signing the week before he announced his candidacy for president in 2007. Shanks thought she would teach high school English when she finished her bachelor's degree in English literature at ASU in 1972 and volunteered at the Free Learner Society, an alternate to public schools that enhanced learning and creativity, where she met her future partners.

Little did Shanks know she would wind up running one of the most popular independent bookstores in the country, which she opened with Bob Sommer, her future husband, and Tom Brodersen—all hippies at the time, interested in reselling used or out-of-print books that might be hard to find elsewhere. They got it off the ground and at first ran it as a worker-owned collective. Changing Hands Bookstore began on April Fool's Day in 1974 in a 500-square-foot space on Fifth Street and moved to a 1,723-square-foot space on Mill Avenue in 1978, which grew to fill 5,000 square feet as they knocked down walls and added levels. Their current Tempe location at McClintock Drive and Guadalupe Road opened in 1998, a 13,000-square-foot space shared with the Wildflower Bread Co. When celebrity authors come through Arizona, they stop at Changing Hands, which regularly brings in such big names that they often hold the lectures and book signings at nearby school auditoriums. But the store also helps smaller local authors make their mark and is connected to many philanthropic organizations, literacy groups, and schools in the valley.

The business has won numerous awards, like Tempe Chamber of Commerce Small Business of the Year in 1994, and Gayle was honored as a 2006 Woman of Valor at a Hillel at ASU fundraiser. The bookstore has such a loyal following that Changing Hands opened a second store in central Phoenix, just off the light rail. Gayle Shanks's advice for success is, be passionate and immediately and always immerse oneself in the needs of the community.

Gentle Strength Cooperative

Gentle Strength Cooperative began as an organic bulk food–buying club that expanded to a shop and lunch area in 1972 on Fifth Street, pictured here. By 1985, it filled a 15,000-square-foot store and deli on University Drive, where customers could work in trade for discounts or just shop for all things natural, before Whole Foods and other natural markets were widespread. The store closed in 2011, not surviving a third move to the southeast corner of Mill and Southern Avenues.

Circle Dancer (OPPOSITE PAGE)

Debbie Elman was involved in Changing Hands Bookstore back when it was initially run as a collective; she worked there until 1999. She was also a member of the bulk food–buying club that became Gentle Strength Co-op back when it was still a small club—before it grew to a membership of over 4,000 people—that distributed food through the Tempe Peace Center (now a Lutheran church). Elman (bottom) managed the Gentle Strength on Fifth Street and remembers the regular picnics the members held at Tempe Beach Park. The store, the community meeting room, and the free store for clothes—where Debbie's sister Sherry volunteered—are missed. Debbie's love of things peaceful inclined her to conduct Sacred Circle dances (top) every month in Tempe from 1989 through the mid-2000s. (Courtesy of Debbie Elman.)

House of Tricks

Robin and Robert "Bob" Trick's garden-style restaurant and patio bar is a favorite spot, nestled in a canopy of trees on Seventh Street far enough from Mill Avenue to quiet city sounds. The couple met in 1985 when both worked at Bandersnatch Pub. They married in 1986 and started remodeling a 1920s cottage for their oasis in the desert, which opened in 1987 with Bob as the first chef. They expanded to the neighboring 1903 historic adobe cottage in 1994. Tricks is on many top lists, and the 2014 *Jewish News* Best of Jewish Phoenix called it the "most romantic restaurant." Robin was named the 2012 Tempe Business Woman of the Year. The gardens at Tricks are tended by Bob's mother, Mary Trick, leaving the couple more time to support various art and charity events. (Courtesy of Robin Trick.)

Haji-Baba

Owners Zuhier Khatib and Nabil Torfa (center front) have run Haji-Baba—a Middle Eastern restaurant and grocery store—since 1989. A local favorite, the place inspires loyalty amongst its employees, too, with Omar Homsi (front right) managing since 1991 and Candelario Almanza (back center) cooking since 1986 (for previous owners). Similarly, assistant manager Adil Rahee (front left), cook Nadem Zaia (back left), and waiter Ali Jumat (back right) are all working on their second decade there. Many short-term employees from the student population, especially from Syria, have worked there over the years, finding the place a home away from home for a few years and staying in grateful contact later as they go on to make their marks in the world. The casual family-like vibe stems in part from the reminder, pictured below, that hangs on their wall. (Courtesy of Haji-Baba.)

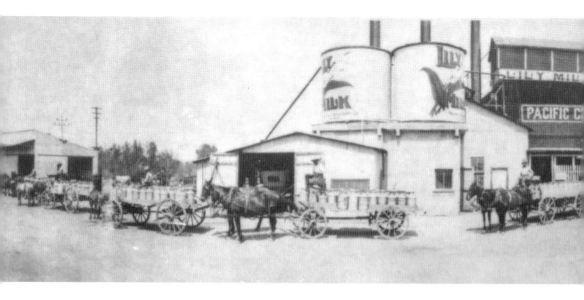

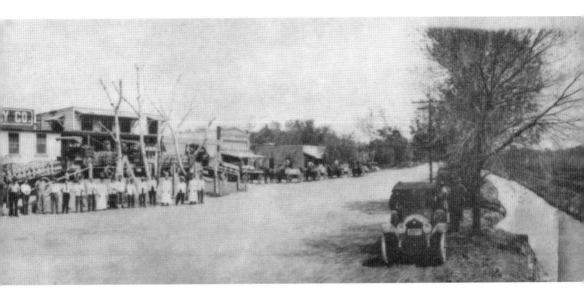

Four Peaks Brewing Company (ABOVE AND OPPOSITE PAGE)
Pictured opposite from left to right in 2013, beer enthusiasts Jim Scussell, Arthur Craft (chef), Randy Schulz, and Andy Ingram (brewer), the owners of Four Peaks, tease that if they brewed beer they could drink for free, but their passion is serious business. The brewery opened in 1996 in an 1890 historic building that was a creamery (Pacific and then Borden) until 1953. Starting with a keg business distributing solely to restaurants, they gradually expanded offerings in their 29,000-square-foot location to include a tasting room in 1997 and a restaurant and bar in 1999 serving over 10 kinds of their brews daily. They distribute by keg, can, and bottle, and, at last count, have over 1,200 tap handles across Arizona. Four Peaks added a second restaurant in Scottsdale in 2005 and a second brewery (58,000 square feet) in Tempe in 2012. (Opposite, courtesy of Four Peaks Brewing Company.)

Café Lalibela

Atsade Desta (center) is the hard-working chef at Café Lalibela, Arizona's first Ethiopian restaurant, which opened in Tempe in 1997. With the help of family such as daughter Salem Beyene (right) and Salem's husband, Anibal Abayneh (left) their initial success continues. They recently partnered with Whole Foods to stock their tasty dishes for home preparation and ready-to-eat foods at the deli and are preparing to open retail space next to their restaurant. For those who are curious, the restaurant shares a name with a holy city in northern Ethiopia and a rock-hewn medieval Christian church by that name commissioned by King Lalibela. (Courtesy of Café Lalibela.)

CHAPTER FOUR

A Good Time
Was Had by All

There is fun to be had in most any time and place, and Tempe likely has something for nearly every style and taste. This is aided by Tempe's university town identity, with students from over 120 countries coming to study, bringing with them a desire to appreciate the local offerings but also influencing what becomes available, as restaurants, markets, and entertainment opportunities evolve to cater to a multicultural population. Even as a pioneer town, Tempe had more entertainment options than many other places in the territory, as the Territorial Normal School students performed plays and drills for the local citizens to watch, adding more kinds of displays, exhibits, and performances as the curriculum changed and enrollment grew.

Tempe has long, hot summer days, so swimming continues to be a favorite activity. Now people enjoy public pools like at Kiwanis Park as well as Big Surf Waterpark, but in the early days, the Salt River (Rio Salado) flowed freely, and early accounts of swimming there in the safer and shadier areas near the banks are common. Later, the system of upstream dams changed the relationship to the river and how water was managed and used. Many remember with great fondness the 1923 Tempe Beach Park, back when it had three pools: a baby pool, a medium-sized pool, and Arizona's first Olympic-sized pool, where two national swim meets were held in the 1930s. Over time, a river-rock bathhouse, bleachers, baseball diamond, skating rink, and tennis courts rounded out the amenities and recreational opportunities. Dwight "Red" Harkins even showed outdoor movies there in the summer of 1934.

Times change and so did Tempe Beach Park, but sometimes improvements do not improve things, or so say the Tempe residents who miss the early version of the park. A drastic modernization in 1964 stripped the park of, among other things, its cottonwood trees and, thus, much of its shade and charm, starting the pool's demise. Public pools were being built elsewhere in Tempe, reducing swimming demand at the earlier location. Closing about 1985, the lovely river-rock fence remains as a hint of the past, and as in the past, there are cheerful faces of people having fun and relaxing at Tempe Beach Park in its new form. With the advent of the nearby two-mile-long Tempe Town Lake in 1999, a wider range of water activities were reborn.

Tempe Beach Park often hosts concerts now, and the music scene in Tempe has deep roots and enticing variety. Some say that Mill Avenue was as or more happening than any other music scene in the country back in the 1970s, 1980s, and early 1990s, spawning international-level careers for local artists and attracting many visiting bands. After that, corporatization and higher rents reduced the number of funky clubs, record stores, and the sorts of restaurants that offered song and dance. Music is still alive and well even if the downtown scene is very different, and it will be exciting to see what new creativity springs from Tempeans as the city continues to evolve.

Fiestas Patrias

The Fiestas Patrias are the five public patriotic holidays in Mexico that continued to be celebrated in the Arizona Territory. This photograph of Magdalena Gonzalez Sigala, Cresencio Sigala's wife, notes that she was the Fiesta Patrias queen in 1897 on September 16, which is the Aniversario de la Independencia, or Independence Day—when Mexico declared independence from Spanish rule, not Cinco de Mayo (May 5) as many citizens of the United States believe.

Girl's Softball

Magdalena and Cresencio Sigala's daughter Sophia (front) followed in her father's footsteps in actively working to help others. After graduating from the Territorial Normal School in 1926, where she was catcher for the girls' softball team, she became a home economics teacher for the US Department of Agriculture. Sophia taught West Phoenix Mexican families about homemaking and sanitation in migrant camp conditions, and during World War II she established food programs for Mexican workers imported to Phoenix to do agricultural work.

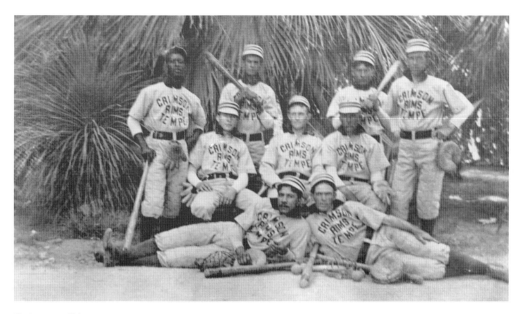

Crimson Rims

Physical activity was common entertainment before televisions and computers ruled the day. For instance, the young town of Tempe had a multiracial baseball team, pictured above in 1899, called the Crimson Rims after a brand of bikes carried at the bicycle shop run by E.P. Carr, seated at left. They played Mesa and Phoenix teams until at least 1906, drawing large crowds. Historians are not sure who the African American player might be, although some early black residents, including Theodore Thomas and John Wesley Boggs, were known baseball players. Baseball continues to be a popular sport to play and watch in Tempe, with residents rooting for the home team—whether for the neighborhood school, a city league, ASU's Sun Devils, or the Los Angeles Angels of Anaheim when they come to Tempe Diablo Stadium (below) for spring training.

May Poles

Beyond sports for the normal school and town leagues, the elementary schools and high schools provided entertainment for the students, their families, and the larger community, like the above 1913 May Day activities at the original Tempe Union High School. The school was established in 1908 at Tenth Street and Mill Avenue after the normal school no longer accepted students with only eighth-grade diplomas. The original school burned in 1955.

The Buffaloes

Tempe High varsity football began in 1924, even though the school did not have its own field until 1969 at its current Mill Avenue and Broadway Road location, at the edge of town at the time. Football games were exciting, even more so when coach John Zucco (pictured) led the team to a 32-6-1 record (including an 18-game winning streak) and to its first state championship in 1956. (Courtesy of Joe Spracale.)

Joe Selleh

Selleh Sporting Goods supplied clothes and equipment for local sports. Joe Selleh (far left) came to Tempe in 1928 to play for a professional baseball team and then finish his education at ASC/ASU. He served on the parks and recreation board and helped start the first Boys and Girls Club in Tempe. A high school award for outstanding athleticism is named in his honor, as is a track in ASU's Sun Angel stadium. (Courtesy of Harry Mitchell.)

Humanities

Some folks prefer theater and music-related activities. Here, Roger Clyne (second student from right) learns from humanities teachers Ann Theibert and Warren Dennis. Clyne, a 1986 McClintock High graduate, became famous with his band the Refreshments and later with the Peacemakers. The band occasionally comes home to play at events such as the opening of the light rail system in 2008.

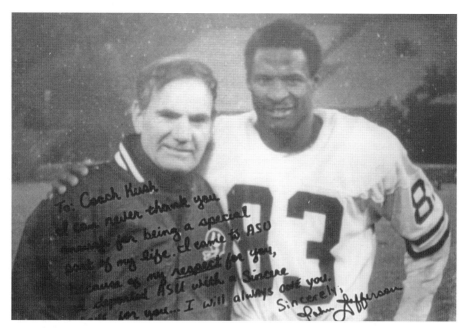

Frank Kush

As the normal school grew, so did the sports offerings. Frank Kush (above left) is the most legendary coach in ASU's history for his winning 22-year football record. He was tough but fair and had his coal-mining family's strong work ethic. Some questioned his style but most appreciated it, like John Jefferson (above right), who helped ASU win the 1975 Fiesta Bowl against the Nebraska Cornhuskers. The Fiesta Bowl came into being during Kush's tenure and was a huge entertainment and economic boon to Arizona from 1971 to 2007, when it moved to Glendale's new stadium. Until then, the Arizona Cardinals also played in Tempe in ASU's Sun Devil Stadium but in an expanded version from the 1958 one seen below. The stadium is currently undergoing another renovation that would astound the players of the first team, fielded in 1897. (Above, courtesy Frank Kush.)

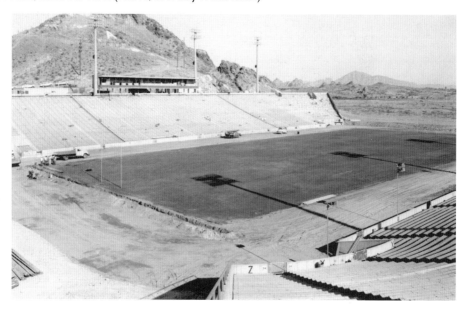

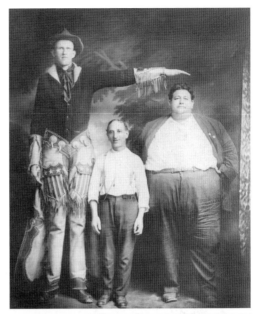

Teodulo Valenzuela

Circuses require stadium-sized spaces, as Tempean Teodulo Valenzuela discovered. First appearing in sideshows in 1920, when reaching 745 pounds, he toured with Barnum & Bailey Circus in 1924 as the "World's Fattest Man." At 800 pounds, he stopped touring but continued appearing at Coney Island. Leaving behind a wife and three kids, he died at about age 40 in 1926. Some 40,000 attended his three-day funeral viewing.

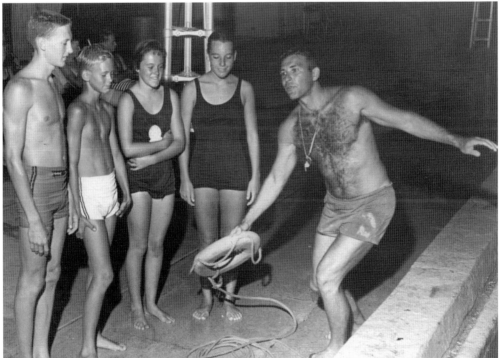

Lifeguard and Educator

An educator award honors Joseph Spracale, longtime Tempe teacher and administrator (1957–1991). After retiring, the Tempe High and ASU alum's efforts continued with the Tempe Impact Education Foundation, ensuring needy kids had clothes and supplies for school. His summers at Tempe Beach Park teaching swimming and lifeguarding are remembered by many who visit at the yearly Tempe Old Settler potlucks, which Joe and his wife, Sandy, help coordinate. (Courtesy of Joe Spracale.)

Big Surf

Engineer "Skipper" Phil Dexter (above) provided a unique option for relief from the summer heat when his award-winning design for Big Surf opened in Tempe in 1969, America's first wave pool and forerunner of waterparks everywhere. The world's worst surfer, by his telling, the former naval captain found waves beautiful, even more so when people were riding them. After smaller trial versions at his home and a Phoenix pool hall, Big Surf—first mostly funded by Clairol, which wanted to promote its "surf look"— opened to nationwide attention, including articles in *Life*, *Sports Illustrated*, and *Time*. The 7.5-acre site has added waterslides and a zip line. Most of the day, people ride waves on rafts, but an hour or two each day is for surfers using hard surfboards to honor the park's original purpose as a surf center. (Courtesy of Big Surf Waterpark.)

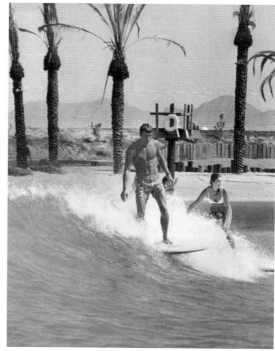

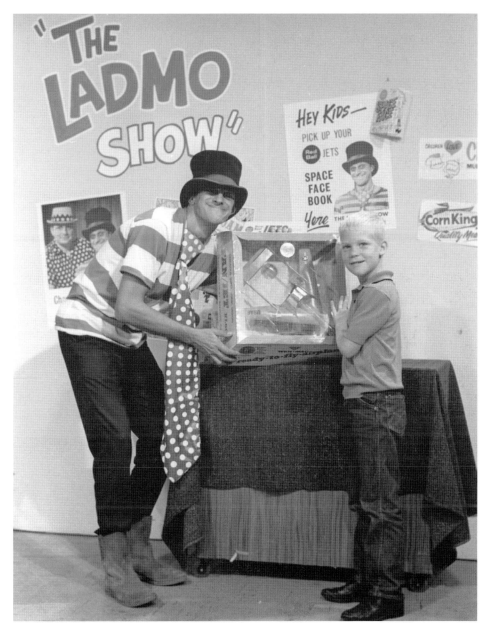

Ladmo

Bill Thompson and Ladimir Kwiatkowski, "Wallace and Ladmo," performed all over the valley as an outgrowth of their popular daily children's show yet with humor carefully crafted to appeal to adults as well. Ladmo (pictured) attended and played baseball for ASU, captaining the team in 1952. After graduating with a journalism degree, he joined KPHO-TV as a cameraman before cohosting the Emmy Award–winning *Wallace and Ladmo Show*, which ran from 1954 to 1989 in Arizona. Active in the community during and after his television run, he was greatly mourned when he died in Tempe. His funeral at Our Lady of Mount Carmel on Rural Road was such an event that helicopters hovered over nearby neighborhoods most of the time, monitoring the traffic blockages. (Courtesy of Kwiatkowski family.)

Finley Brother Rodeo Stars

The Finley brothers were international rodeo stars when it was akin to being a rock star, from the 1930s to the 1950s. The local ranching brothers, Luther, Frank, and Larry, shown from left to right in 1947, were naturals, often winning at competitions from the Cow Palace in San Francisco to Madison Square Garden in New York City. They also had other talents. For instance, Luther won the 1937 and 1939 world championships in wild-horse racing, and earned a doctorate from Bradley University in 1954 with a dissertation titled "Computing the Line of Position in Celestial Navigation." He taught engineering at ASU. Larry was not only a world-champion bareback rider in 1947 and all-around champion, he was in over 50 Western movies and television shows. Title-winner Frank also went on to be a casino pit boss in Las Vegas.

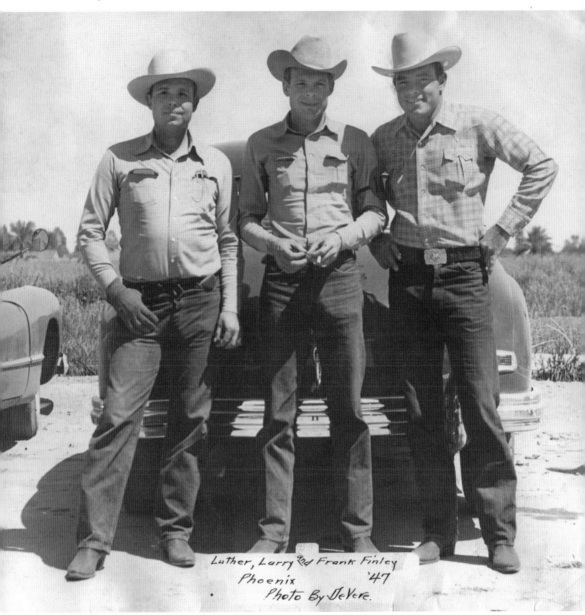

Luther, Larry and Frank Finley
Phoenix '47
Photo By DeVere.

Legend City

Western-themed fun was found at Legend City, a 58-acre amusement park created by Louis Crandall, complete with dancing can-can girls. Operating from 1963 to 1983, the park had an Iron Horse—a replica of an 1860 steam locomotive—and a ghost town, Indian and Mexican village recreations, and many rides—including the Lost Dutchman Mine ride and roller coasters—plus entertainment in the saloons and more.

Miss America

Vonda Kay Van Dyke performed regularly with her ventriloquist dummy, Kurley Q, at Legend City, where Salt River Project's main office complex is now. An ASU student, Vonda (wearing hat, with her poodle ViVi) rode in the homecoming parade in front of Hayden Flour Mill after she was named Miss America 1965. (She also won Miss Congeniality at that Miss America pageant.) Her winning personality, pageant wins, and community activities brought nationwide attention to Arizona and Tempe. Among other things, she went on to author five books, including *That Girl in Your Mirror*, and had a successful singing career including recording four albums.

91

Tempe's Showman

As movies became a source of fun, Dwight "Red" Harkins was in the lead. Ambitious and inventive as a child, he sold candy at age seven, saving up for a bike for a paper route. By age 12, the ham-radio operator bought his own printing press, and he built his own television at 15. Arriving in Tempe alone at age 18 in 1933, he opened the State Theatre in the Goodwin Opera House on Fifth Street. In 1940, he built and moved to the College Theatre on Mill Avenue—now the Valley Art—with early innovations like headphones for the hearing impaired, glow-in-the-dark carpeting, and electric water fountains. He married his second wife, Viola, in 1950, and they lived in a studio apartment next to the projection room until 1953. Their son Dan Harkins was "invented" there. (Courtesy of Dan Harkins.)

Harkins Legacy

Red also created Arizona's first public-address system, above, used at the dedication of the Tempe Bridge, at dances, and as the first amplified announcing system at ASC/ASU football games. The volunteer fireman pioneered FM multiplex, earning an honorary doctorate for his efforts, and advanced technology more as co-owner and manager of local radio and television stations. In time, he bought four more theaters, for a total of eight screens. When Red died in 1974, Dan Harkins (left) took over at age 21. He had held every job at the theater, yet faced new challenges as the enterprise teetered on bankruptcy. He persisted and even won a major antitrust battle with the studios that were not supplying big-name movies to independent theaters. Dan grew the chain into the largest privately owned movie chain in the United States, buying and renovating theaters to his own high standards, just like his father. (Left, courtesy of Dan Harkins.)

Childsplay

David Saar's graduate program in child drama at ASU required that he direct, produce, and perform in a show. He created *Will Today Be Yesterday Tomorrow?* and a career was born. The play was performed in the first season of Childsplay, the professional theater for young audiences that Saar (top) founded in 1977 with offices in two small rooms. Childsplay has grown to employ a large company and staff. In addition to plays, it offers classes for all ages in its Academy, and now Childsplay is an internationally-known theater organization in residence at the Tempe Center for the Arts and tours nationally offering quality plays—both classic and original—that assume kids are intelligent and broach issues that they grapple with in today's society. Producing a play takes dedicated team members like Rebecca Akins—a talented costume, puppet, and prop designer—who has brought many plays to life for over 40 years, and for Childsplay since the mid-1980s. One of her sketches for *Island of the Blue Dolphins*, mounted by Childsplay in the 1998–1999 season, is seen at bottom. (Top, courtesy of David Saar; bottom, courtesy of Rebecca R. Akin Papers, Child Drama Collection, Arizona State University Libraries.)

The Yellow Boat
David Saar's play *The Yellow Boat* brought Childsplay national awards and a production at the Kennedy Center in Washington, DC; it continues to be produced worldwide. The play transformed the loss of Saar's son Benjamin—who died at eight in 1987 of AIDS contracted from a hemophilia-treatment blood transfusion—into a celebration of life. Archivist Katherine Krzys shows young actors Benjamin's paintings to help them interpret the play. (Courtesy of Lynn Trimble.)

Creative Volunteer
After retiring in 1996 from 23 years as a professor of theater for youth at ASU, Lin Wright volunteered 14 years at Broadmor Elementary School, often bringing a dog. One program, of many, involved the children writing letters to her dogs. She and her husband, Jim, wrote back as the dog, signing the letters with a real paw print. The kids read the letters aloud to the class. (Courtesy of Katherine Krsyz.)

Colleen Jennings-Roggensack

Major Broadway shows tour through Tempe at ASU's Gammage Memorial Auditorium due in part to the leadership of Colleen Jennings-Roggensack, who has served as executive director since 1991. She is currently also assistant vice president for cultural affairs at ASU. The former dancer and choreographer brought the Frank Lloyd Wright–designed building into the 21st century, maintaining the beauty and integrity of the building while permitting larger productions. Colleen has also commissioned at least 22 works that premiered in the 3,000-seat performance hall, a venue known for, among other things, its balanced acoustics and no seat being more than 115 feet from its versatile stage. With Colleen's guidance, Gammage has grown into the largest university-based presenter of the performing arts in the world, resulting in nearly $1 billion of positive economic impact to Tempe and surrounding areas. In addition to administrating events at Gammage—which also include lecture, celebrity, and presidential campaign events—Colleen's domain includes events at ASU's Kerr Cultural Center, and non-sports events at Sun Devil Stadium and Wells Fargo Arena. Additionally, she is Arizona's only Tony Award voter, which requires frequent trips to New York to see the shows. Colleen uses her expertise to help the community in various ways, both locally and nationally, including serving on many boards. Her service brings additional attention to Tempe, as she has won an impressive string of state and national awards and appointments, including a presidential appointment to the National Council of the Arts (1994–1997), as well as appointments to work with the National Endowment for the Arts and the Department of Education on the arts education planning process. Colleen is especially proud of efforts to connect youth to the arts, bridging cultural and economic divides, as many youth get no exposure to the theater in school. Some of the benefits that young people get from these programs—besides fun—include increases in self-esteem and better attitudes toward school, making them less likely to drop out. Some are even inspired to pursue a career in theater. (Courtesy of Tim Trimble/ASU Gammage.)

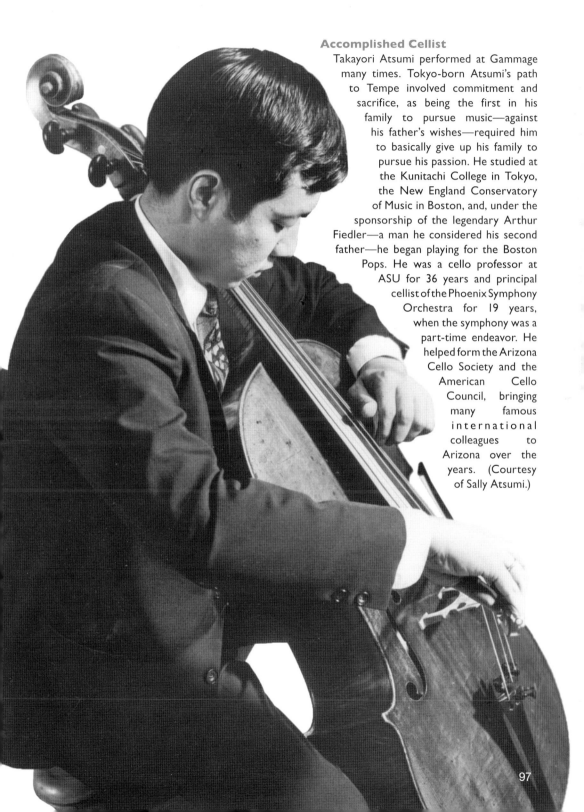

Accomplished Cellist

Takayori Atsumi performed at Gammage many times. Tokyo-born Atsumi's path to Tempe involved commitment and sacrifice, as being the first in his family to pursue music—against his father's wishes—required him to basically give up his family to pursue his passion. He studied at the Kunitachi College in Tokyo, the New England Conservatory of Music in Boston, and, under the sponsorship of the legendary Arthur Fiedler—a man he considered his second father—he began playing for the Boston Pops. He was a cello professor at ASU for 36 years and principal cellist of the Phoenix Symphony Orchestra for 19 years, when the symphony was a part-time endeavor. He helped form the Arizona Cello Society and the American Cello Council, bringing many famous international colleagues to Arizona over the years. (Courtesy of Sally Atsumi.)

Art Classes

Many enjoy art exhibits or taking classes. World-class artist Lawrence Tenney Stevens offered painting and sculpture classes in Tempe, the first locally to include studies of live human nude figures—common practice for serious students. Stevens (far left) is seen in his Tempe studio with, from left to right, student Harriet Swick, his wife, Bea, and philanthropic art patron and student Katherine Herberger, namesake of the Herberger College of Fine Arts at ASU. (Courtesy of John Faubion, Lawrence Tenney Stevens Trust.)

Award-Winning Sculptor

Stevens moved to Tempe in 1957 after interrupting his artistic pursuits twice to serve in both World War I and World War II, including a secret mission to Africa. The Bostonian won the prestigious Prix de Rome (1922) for *Music* (pictured) earning three years of worldwide art study and inspiring his patriotic feeling to develop a style more reflective of American strength than the sentimental European style he had learned. (Courtesy of John Faubion, Lawrence Tenney Stevens Trust.)

Self-Portrait Sculpture

Stevens, pictured here with his self-portrait, moved between styles with ease, with work varying in size and focus from an allegorical 25-ton, six-story tall *Tree of Life* for the 1939 New York World's Fair—the largest wood statue in the world—to smaller lifelike figures, linocuts, and cowboy high-style bronzes, many of which graced Valley National Banks before acquisition by the J.P. Morgan Chase Collection. (Courtesy of John Faubion, Lawrence Tenney Stevens Trust.)

Decisions, Decisions

Rudy Turk directed ASU's art collections from 1967 to 1992 and was a major positive influence on arts in the community. When Stevens died in 1972, his wife offered to donate portions of the Stevens archives to ASU. Turk declined, but 25 years later declared the greatest mistake of his career was not embracing the collection, as Stevens had one of the most complete archives of an American artist.

EL BAJO (THE BASS) PLAYED BY JOSE MARIA ARROYO
OTHER MUSICIANS NOT RECOGNIZED

Arroyo Musical Roots

Music comes with people. Jose Maria Arroyo moved his family to Tempe in 1919. He first served as overseer at Steels Ranch on Priest Drive, then bought land where he raised vegetables and animals to sell, but he was probably most well known as a musician, shown here with his bass in 1942. His wife, Marquita, who played the harp, and his children also embraced music.

Arroyo Legacy

Jose's boys, Victor and Jesus, played in bands with other Tempeans, and his grandchildren continued the musical tradition even as they served in the military, like Hank and Louie (shown here) who served in the Korean War in the early 1950s. Both served in the 25th Infantry Division; in addition to carrying their rifles, they played their horns and would play maracas on salsa songs for their infantry band.

Chapito Chavarria Orchestra
The musical Chavarria family also left its mark. For instance, Pablo Chavarria Jr. played guitar with Victor and Jesus Arroyo, Ben Gamboa, and Castellano in a band, but probably Rafael "Chapito" Chavarria garnered the most valley-wide popularity in big valley dance clubs from the 1940s. He retired in the 1980s for the most part but continued playing some weddings and events. Chavarria is pictured here at center with bass; saxophonist Alfred "Chalio" Dominguez is at far right. Chavarria's orchestra was sought by multiple generations of citizens, who often planned their wedding dates around its availability. His longevity helped build cohesiveness in Hispanic communities, and contributions were noted in exhibits at both the Musical Instrument Museum and the Tempe History Museum. Dominguez could have toured with Tito Puente, but he stayed local to focus on family. (Courtesy of Dolores "Lola" Tobin Dominguez and family.)

Visionary Musician

Music styles change. Hans Olson, pictured at left in 1970, has been long-loved for his music, especially his ballads and boogie blues, both in Tempe and during his 35 years of international touring. With over 70 original songs and 13 independent record releases, he rocks clubs, and now his music plays in television shows. Caring deeply about music and other musicians, he inspired the creation of the nonprofit Arizona Music and Entertainment Hall of Fame (AMEHOF) in 2002. The idea grew out of honoring Chico Chism, an international blues legend, pictured below with Olson. Chism called Arizona home since 1987 and was often seen on Mill Avenue in his trademark suit and hat. After living mainly online for years, the AMEHOF landed a good physical location in partnership with Pranksters Too, just north of Tempe, in 2015. (Courtesy of Hans Olson.)

Music is Art

Musicians, including Chism, liked eccentric street artist Frankie "Elvis the Cat del Monte" Martinez enough to attend his funeral. The flyers Martinez made for bands and his collage art, often including the words "Elvis the Cat loves you," he sold for $5 were known around the local music scene. He used to get up on stage to sing when a band did an Elvis Presley song. Frankie is remembered for bicycling around town, being kind to birds and stray cats, and for his friendly personality. Other musicians at the funeral included Brent Babb of Dead Hot Workshop and longtime valley favorite Walt Richardson (below), a reggae mainstay in Tempe with his Morning Star Band. Richardson is an educator, fundraiser, and host of Songwriters' Showcase and Walk in Wednesdays at the Tempe Center for the Arts. (Right, courtesy of Curtis Grippe.)

Gin Blossoms

Elvis the Cat was often seen when the Gin Blossoms—with McClintock High School graduates Doug Hopkins and Bill Leen—took the stage at local haunts like Long Wong's, where they played about 150 shows in 1989 alone, or at Nita's Hideaway. The Gin Blossoms scored international fame, starting with the 1993 summer hit "Hey Jealousy," and brought attention to Tempe with songs such as "Mrs. Rita," which features a fortune-teller on University Drive (see page 123).

Nita's Hideaway

Bands need a stage, and Nita's Hideaway was a popular choice as the neighborhood bar by day became a music venue at night. Nita Craddock was a 1949 Junior Rodeo Queen (pictured) and a professional barrel racer from 1969 to 1971. In 1975, she opened Nita's Hideaway and ran it successfully until selling in 1999, which led to a 2004 closure. Nita has volunteered at Tempe St. Luke's hospital since 1998 and won 2014 Volunteer of the Year. (Courtesy of Nita Craddock.)

Sound Engineer

Great music experiences include more than musicians. Recording engineers like Clarke Rigsby play a big role in passing quality sound on to the world. Since 1980—and since 1983 in his Tempe-based Tempest Recording studio—Clarke uses his technical savvy while working with an impressive array of well-known musicians across genres. He also teaches future sound engineers in classes at ASU. (Courtesy of Clarke Rigsby.)

Hoodlums

Radio stations, like Tempe-located KUPD, and record stores play a role too. Tempe has had many record stores, including the long-popular Zia Records and Tower Records. Now gone, and missed, is Hoodlums New & Used Music (later Hoodlums Music and Movies), which Steve Wiley and Kristian Luce owned from 1998 until 2012. Steve also wrote two *New Times* columns, *Record Store Geek* and *Parent Hood*, until his unexpected, and mourned, death in 2014. (Courtesy of Hoodlums.)

Racing Legends

For some, the need for speed is more of a draw than music. Before retiring from racing in 1996, Lealand McSpadden, the "Tempe Tornado" (pictured), won numerous victories, including the 1978 Western World Sprint Car championship. Inducted into the Arizona Motorsports Hall of Fame and the National Sprint Car Hall of Fame in Iowa, he has loyal lifelong fans such as Ellen Ellis, who photographed most of his races. Other racers like Ron and Billy Shuman—the sons of Bill and Nadene Shuman and grandsons of Gene and Irene Bishop (see page 66)—received ample local and national attention as well. Early locals Jerry Brock (see page 53) and James Albert "Al" Kitts (who moved to Tempe at age four in 1929) were friends with Shuman and McSpadden and were actively involved in various aspects of automobile racing, too, via sponsoring, building, repairing, and racing the cars. For instance, Al built or adapted many cars himself—including roadsters, midgets, and sprints—and was well known for making them speedy. He worked in Spain's Garage until it closed when the city needed the land for the new city hall in the late 1960s; then he opened Kitts Automachine. Kitts was inducted into the Arizona Motorsports Hall of Fame in 2005, as was Billy Shuman in 1994 and Ron Shuman in 2001. (Courtesy of Ellen Ellis.)

CHAPTER FIVE

Heart and Soul

Regardless of what one does for a living or to pass the time, peoples' beliefs affect tangible and intangible aspects of their daily life and how they interact with the community. Many kind-hearted and selfless acts generate from believers and nonbelievers of all types. Whether one subscribes to a certain religion or not, whether one considers oneself "spiritual but not religious," or is a proud agnostic or atheist—shared virtues and values bring people together. Beliefs about metaphysical matters vary as much as beliefs about the proper way to care for physical health.

As the heart and soul of a city is its people, the variety of belief systems they hold make up the rich fabric of life. The tapestry of Tempe is particularly rich, as it reflects the diversity of its population. Whether considering approaches to healing the body—reflected in conventional medicine options or the naturopathic and integrative approaches practiced at the Southwest Institute of Healing Arts or the Southwest College of Naturopathic Medicine—or whether considering philosophies of the meaning of life, someone in Tempe has probably considered its merits and possibly talked to a neighbor about it, delivered a speech, or wrote a book about it, especially given the number of ASU faculty who live in Tempe.

How each person cares about him or herself, others, and the world reflects personal choices, and some have committed their lives to helping in medical or spiritual service through their choice of career. Tempe's history is rich with skilled doctors and ministers, and especially in the early days, people often wore many hats. Some folks served as both a physician and a minister to help the small community along in more than one way or satisfy their own multifaceted interests. Tempe's first doctor, John L. Gregg, served in that dual capacity, as did Dr. Ernest Pohle, who both started what is the current Tempe St. Luke's Hospital and served actively as a Seventh-day Adventist.

Religious tolerance factored into the development of Tempe. Beyond Hayden's Ferry and San Pablo, the two initial communities that formed what is now the city of Tempe, a third "founding" group and area of downtown was a Mormon settlement peopled initially by Benjamin F. Johnson's family. En route to bringing his faith to Mexico, Johnson changed plans and bought acreage from the welcoming Charles Trumbull Hayden at a time when some were unfriendly to Mormons due to their polygamist practices. Johnson put down roots with his seven wives and accompanying children, nearly doubling the population of Tempe.

Whether a born-again Christian, a dyed-in-the wool atheist, or anything in between, a faith healer, or a doctor, Tempe's eclectic community acknowledges the freedom to believe and behave as one chooses—within the law. Even in the case where students or more permanent residents exercise their right to publicly protest something others hold dear, at the end of the day, Tempeans can take pride in a community that, by and large, respects diversity.

First Tempe Doctor
Dr. John L. Gregg, the first doctor in Tempe, with his wife, Mollie, arrived at Hayden's invitation in 1877. Despite losing a leg, the Civil War surgeon led an active life. Beyond doctoring, Gregg raised bees, farmed 160 acres, served four years as county supervisor, and ministered in the Southern Methodist Church. In 1895, he opened a small mission sanctuary on East Eighth Street complete with Spanish-language hymnals, which ran until the 1950s. (Courtesy of Sue and Bob Enright.)

First Appointed Mayor
New York–educated Fenn Hart opened a private practice and drugstore in Tempe in 1888 after serving three years as doctor and school director at the San Xavier Indian Reservation near Tucson. He was Tempe's first appointed mayor (1894–1896), and was on the town council until 1900, aside from time as a Red Cross doctor in the Philippines during the Spanish-American War, where he served as a battlefield surgeon and cared for smallpox patients.

Hart's Varied Interests

Hart, like many people of book learning then, served on the Territorial Normal School Board of Education, from 1889 to 1891. The mantel in his Tempe home shows some of his professional interests and weapons for protection in war or territorial travels. His family stayed in Tempe when he went to Jerome to doctor for mining companies from 1901 to 1917, when the family moved to Phoenix to be together.

Mormon Pioneer

Benjamin Franklin Johnson, an early Mormon pioneer and brother-in-law to prophet Joseph Smith, was a New York–born nurseryman, among other things. He moved to Tempe in 1882, buying land from Hayden and helping him and others—including Dr. Gregg—learn beekeeping. In an 1884 letter, he reported having "45 stands of bees" from which he extracted two tons of honey and multiplied his initial 70 swarms to 200—plenty to share.

Johnson loved Tempe, initially choosing it over Mesa, as the nearby river and shade trees made it cooler. In a letter he called it "the land of almost constant spring and summer" and described his 100 fig trees measuring 10 feet high and 10 feet wide with five-inch-thick trunks. He also reported on his peach trees and grape vines, from which he had, at that writing, harvested 35 pounds of fruit, which is a good thing, as he had many mouths to feed. With seven wives, he had 45 children and 374 grandchildren, increasing Tempe's population quickly before most of his family moved to 180 acres he acquired west of Mesa at the now Southern Avenue and Dobson Road area originally called Nephi.

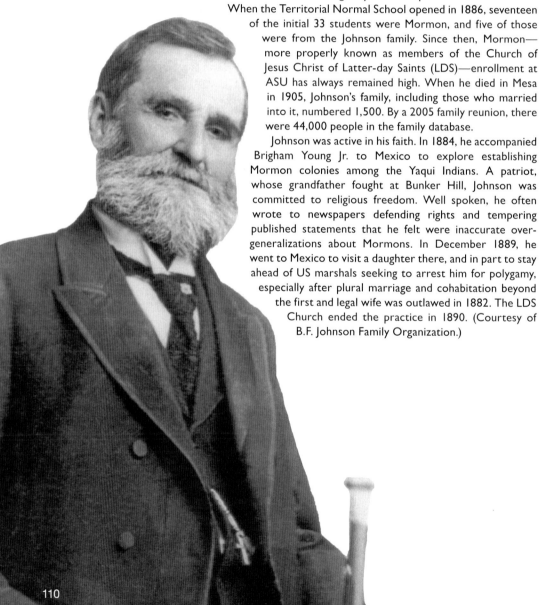

When the Territorial Normal School opened in 1886, seventeen of the initial 33 students were Mormon, and five of those were from the Johnson family. Since then, Mormon—more properly known as members of the Church of Jesus Christ of Latter-day Saints (LDS)—enrollment at ASU has always remained high. When he died in Mesa in 1905, Johnson's family, including those who married into it, numbered 1,500. By a 2005 family reunion, there were 44,000 people in the family database.

Johnson was active in his faith. In 1884, he accompanied Brigham Young Jr. to Mexico to explore establishing Mormon colonies among the Yaqui Indians. A patriot, whose grandfather fought at Bunker Hill, Johnson was committed to religious freedom. Well spoken, he often wrote to newspapers defending rights and tempering published statements that he felt were inaccurate over-generalizations about Mormons. In December 1889, he went to Mexico to visit a daughter there, and in part to stay ahead of US marshals seeking to arrest him for polygamy, especially after plural marriage and cohabitation beyond the first and legal wife was outlawed in 1882. The LDS Church ended the practice in 1890. (Courtesy of B.F. Johnson Family Organization.)

Niels Petersen

Niels Petersen arrived in 1871 from Denmark after traveling the world seven years in the English merchant marines. Starting with a 160-acre parcel, he gradually increased his holdings to over 1,000 acres. He held positions of influence in Tempe and the Salt River Valley and cofounded the Tempe Methodist Episcopal Church. In 1892, James Creighton designed Petersen's Queen Anne Victorian–style house (below) on the corner of Priest Drive and Southern Avenue, listed in the National Register of Historic Places since 1977. The house stayed in the family over two decades after Petersen's 1923 death and was later held by the Independent Order of the Odd Fellows from 1968 until it was donated to the city in 1979. The house's large lawn held community picnics and socials in Petersen's day, and events are still held at the restored house today. Flags were flown at half-mast when Petersen died.

Doctor and Governor

Dr. Benjamin B. Moeur worked as a cowboy in Texas when he fell in love with Honor Anderson, his boss's daughter, after seeing her photograph. Told she would never marry a cowboy, he went to medical school, graduated at the top of his class, and married Honor on his way to Tempe in 1896. A country doctor, among other worthy pursuits, he made house calls throughout central Arizona—no easy task at the time—winning him friends across the territory. That served him well when he ran for governor, and Moeur served two terms from 1933 to 1937. Known as a controversial governor with a fiery temper and saucy language, he ably helped Arizona survive the Great Depression, implementing luxury taxes, a personal-income tax, and a sales tax, while also reducing property taxes and cutting government expenses.

REV. ROMULUS A.
WINDES
1849 ⋅—⋅ 1932
BE PREPARED BEFORE
YOU COME HERE.

MAGDALENE A.
WINDES
1849 ⋅—⋅ 1936
FOLLOW US TO OUR
HOME IN HEAVEN

Baptist Ministers

Baptist missionary Romulus Adolphus Windes's mule-drawn wagon carried him to and around the Arizona Territory as he seeded six Baptist churches, starting in 1879. He ultimately settled in Tempe, still serving the church and later selling insurance and real estate. His wife, Magdalene—the first published female poet in Arizona—helped start the first public library in Tempe. Their son Dudley became chief justice of the Arizona Supreme Court. Englishman George Poil (pictured) moved to Tempe after decades in Wyoming, continuing his career as a well-regarded deacon in the Baptist Church, where he spent the last six years of his life, leaving his wife, Hannah, and two daughters to continue in the town they loved. His funeral brought deacons from as far as Yuma and Wyoming. (Top left and right, author's collection.)

Laird & Dines

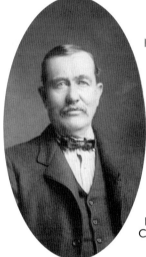

Dr. James Alonzo "Lon" Dines (left) opened Laird & Dines Corner Drugstore in 1897 with the Laird brothers. It was the place for gossip or goods, making it a successful venture and affording Dines modern toys for his children (below). Both Dines and pharmacist Hugh E. Laird (1882–1970) served as city councilmen for many years and as mayors (Dines, 1903–1912; Laird, 1948–1960, also a two-term state legislator), using the building as campaign headquarters and town hall. Keeping pace with change, Laird & Dines added a soda fountain, which students loved until the store closed in 1960. The 1893 building remains, albeit modified, at the corner of Fifth Street and Mill Avenue, and usually houses a restaurant on the second floor, a shop on the main floor, and a piano bar in the basement. Laird's son Clyde helped charter the Kiwanis Club of Tempe in 1952.

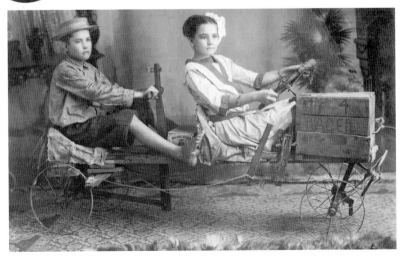

Hospital Founder

Dr. Ernest E. von Pohle, a committed Seventh-day Adventist, cared for his community in body and spirit. Fluent in Spanish, which helped in Tempe and in ongoing foreign medical missionary work, Dr. Pohle—he dropped the "von" during World War II—began practicing in Tempe in 1936. His wife, Myrtle, handled medical records, conducted Bible studies, and wrote a book on missionary work in the Hispanic Southwest. Their two-bed clinic in a farmhouse grew into the 10-bed Tempe Clinic Hospital, and then the Tempe Community Hospital—run by a Seventh-day Adventist group for years—then finally expanding into today's Tempe St. Luke's Hospital. Dr. Pohle delivered many babies as the valley grew. Mary Lou Gertz, a nurse who began working with him in the 1950s, reported that at one count he had delivered 9,000 babies, and once she helped him deliver babies from three different mothers within 51 minutes. Sandy Spracale worked for Dr. Pohle when she got out of nursing school. She remembers once admiring his bolo tie; to her surprise, he took it off and gave it to her. Her husband, Joe, still wears it from time to time. (Courtesy of Ellen Pohle Hardin.)

Catholic School

From left to right, Blessed Virgin Mary nuns Sr. Mary Valeria, Sr. Mary St. Lucile, and Sr. Mary Bertilla taught at Our Lady of Mount Carmel on University Drive in an English-immersion manner, not allowing Mexican children to speak Spanish. Sr. Mary Valeria became principal at the new Our Lady of Mount Carmel on Rural Road for 38 years. The Newman Catholic Student Center acquired the 1903 church in 1962, as ASU student involvement outpaced that of the early families. (Courtesy of Sue and Bob Enright.)

Dr. Marcus "Mark" Westervelt

Dr. Westervelt, seen here preparing polio shots for Tempe High School students, brought his family to Tempe in 1939, building a private practice and serving as the ASU football team's doctor beginning in 1946. Active outside Tempe, too, he served his community and country in many ways, including starting a well-baby clinic in Guadalupe and serving as an Arizona National Guardsman, among other things. The former state staff surgeon was promoted to brigadier general in 1970. (Courtesy of Sue and Bob Enright.)

Important Life Location

Dr. Westervelt's daughter Sue (left) attended the school started in Our Lady of Mount Carmel in 1945 and married Bob Enright there in 1961 (right, see page 40). Her memories inspired her to save the 1903 church by securing its National Register of Historic Places listing in 1978. The church is commonly, and mistakenly per various records, called St. Mary's, since it was dedicated to St. Mary and served by priests from St. Mary's in Phoenix until 1925. To early families, the church is just the new home of the Our Lady of Mount Carmel, whose Rev. Severin Westhoff sought the new location to handle growth as more Anglos came to the 1880s church at the butte (see page 14). Tempe outgrew the second church, too, inspiring a third Our Lady of Mount Carmel, built on Rural Road in 1968. Name confusion aside, many take heart from both places. (Courtesy of Sue and Bob Enright.)

A Successful Arranged Marriage

Tomi Aisawa arrived in San Francisco in 1914 after a 24-day voyage from Japan as a "picture bride" for an arranged marriage to Koryo Nakatsu. The couple arrived in Arizona in 1928 with five children, having four more after. During World War II, they escaped, by half a mile, being relocated to a Japanese internment camp in 1942. They did not escape numerous restrictions and racism, though, as some Tempeans would not sell them goods, and others in the valley would not buy the vegetables the Nakatsus grew. Fortunately, kind neighbors like John and Emma Birchett (opposite, top) knew the Nakatsus were good, patriotic people, so they helped as they could, asking them each morning for a grocery list to get what their large family needed, and helping them sell their vegetables to wholesalers. (Courtesy of the Nakatsu family.)

Nakatsu Ranch Market

Until Tomi's citizenship in 1959 the couple could not own land, so the Nakatsus first leased 40 acres of cotton farm that they converted to vegetables. Not understanding farming in hot Arizona cost them most of their savings within two years, just on the cusp of the Great Depression. Resilient, they eventually bought 38 acres in the names of their children with money Tomi saved in a buried jar since they were not allowed to use banks. In 1951, they built a dirt-floored vegetable hut with a palm-frond roof on University Drive, which was remodeled four times until it was the full-scale 3,500-square-foot Nakatsu's Ranch Market. Their son Jimmy (bottom), was instrumental in the farming endeavor for the market until it closed in 1982. The happy 53-year marriage ended when Koryo died in 1967, leaving Tomi without him until her death in 1980. (Bottom, courtesy of the Nakatsu family.)

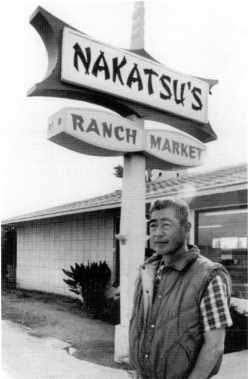

Ayako Okuda

Methodist missionary Rev. Ayako Okuda, the daughter of a Buddhist priest in Japan, reached out to the Nakatsus, teaching the children piano weekly for 10 years and helping in many ways. Impressed by her love, the Nakatsus ultimately renounced Buddhism and accepted Christianity. The relationship grew so strong that the Nakatsus decided to gift the childless widow with a child—the highest honor in the Japanese culture is to give another a child. Tomi and Kory conceived Alice Ayako with this in mind, but Reverend Okuda—founder of the first Japanese Christian congregation in Arizona—died in a car accident in 1939 before the gift could be delivered that year. Alice—a Tempe High grad and onetime co-owner of the Oxbow Tavern on Apache Boulevard—later Murphy's Irish Pub and now Tempe Tavern—grew up with her natural family. (Courtesy of Nakatsu family.)

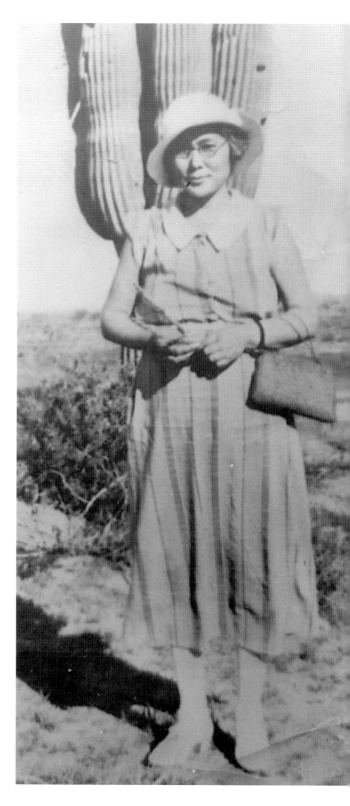

Grace Community Church

As Tempe grew, so did the variety—and often the size—of churches. Grace Community Church was founded by those who in 1965 envisioned a church near the growing south end, which at the time was around Southern Avenue. In 1967, Pastor Guy Davidson gave the first service with 355 people in attendance. The church grew rapidly and now regularly has 1,000 to 1,200 in attendance each week. The choir is pictured here around 1980, singing praises.

University Presbyterian Church

The University Presbyterian Church was selected as the City of Tempe's 2004 Diversity Award winner. Clergymen Al Gephart, left, and Craig Miller were honored for their work building inclusivity for gay, lesbian, bisexual, and transgender people. Embracing diversity is how their members "celebrate the image of God in every person." Diversity is ever-present, whether one follows Jesus, Allah, Buddha, or any other—or none of the above.

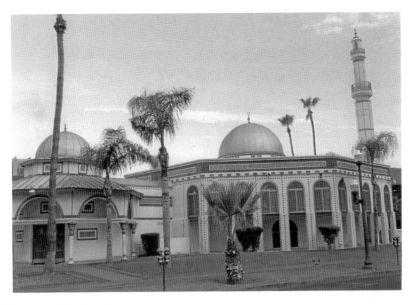

Islamic Community Center

The eight-sided mosque (masjid) in Tempe—modeled after the Dome of the Rock in Jerusalem—that opened in 1984 is a center of peace and worship for all, and an especially fitting place to observe the five daily prayers and Friday prayers for members of the Islamic faith who previously met in homes or drove to Phoenix. A welcome addition to diverse Tempe—their own membership comes from more than 75 nationalities—the programs they offer serve both the Muslim and non-Muslim community, especially students, given the proximity to ASU. Their outreach and interfaith efforts are helpful in correcting the misconceptions that, unfortunately, some people hold when they mistakenly assume that bad acts carried out someplace near or far are representative of all people from a certain region of the world or of a certain faith. (Above, courtesy of Stanley Parkinson.)

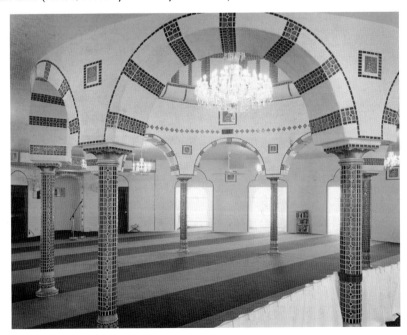

Supernatural and Extrasensory

Some faiths include beliefs about ghosts and spirits. The house built in 1910 by Mary and William Moeur, brother of Dr. B.B. Mouer (see page 112), at Ninth and Ash Streets—now Casey Moore's Oyster House—is said to be haunted. William and Mary died there—in 1929 and 1938, respectively—but other deaths since then could contribute to the experiences reported by some who visit the house, a restaurant since the early 1970s. Hauntings might be explained by Rita Miller's insights into other-worldly matters. A fortune-teller, "Mrs. Rita" opened for business in 1969 (below) in the 1888 Gage House—a historic house originally owned by a physician who also developed property in Tempe from 1888 to 1909. Rita Miller retired, but the business remains with a new sign (inset) communicating a wider range of services for all sorts of spiritual seekers (see page 104). (Inset, courtesy of Stanley Parkinson.)

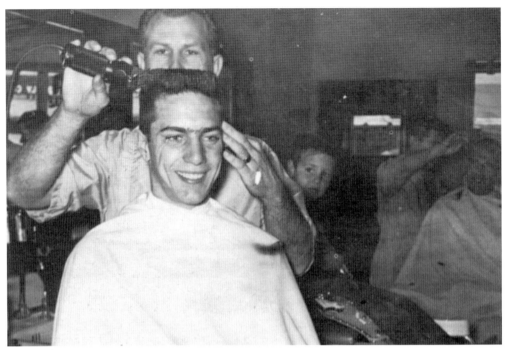

Ray's ASU Barbershop
Self-care and friendships feed the soul. Since 1950, Ray's ASU Barbershop provided a place for 20 minutes of talk therapy per haircut. Ray, pictured with Mike Goodwin, died in 2008 at 82. He is missed, but the popular shop lives on, currently on Lemon Street after 43 years on Mill Avenue. Many Tempe VIPs have been regulars, and five generations of Harry Mitchell's family have had haircuts there. (Courtesy of Harry Mitchell.)

Self-Care Includes Healing
Like Ray, Judy Wilcox's Body Waxing and Harmonic Healing Center serves body and spirit—but differently. She opened in 1992 in Tempe as she liked the variety of people in a university town. Starting in a 10-by-12-foot room at the Arizona Athletic Club on Priest Drive, the demand for hair removal grew and expanded to energy work. Thus, she opened her own 3,000-square-foot building on Rural Road in 2005, employing 12 people. (Author's collection.)

Future Tempeans

Whether one attends a church or believes there is no soul, Tempeans can make peace with differing belief systems by looking for common ground—a skill enhanced through a good education. ASU alum Dr. George M. Sanchez—an optometrist for nearly 60 years before his 2015 death—was an education advocate. His long-term efforts for local schools—including with the Tempe Impact on Education Foundation—inspired the Tempe Elementary School District to name its headquarters in his honor. Education makes a difference that ripples through to future generations, like the three 2015 Tempe history essay winners (below) flanked by school board president Rochelle Wells (left) and councilman Corey Woods. Together, city servants and citizens help groom a generation of Tempeans the founding pioneers would be proud of. (Courtesy of Tempe Elementary School District No. 3.)

INDEX